SCHLÜTER IN BERLIN
STADTFÜHRER
A CITY GUIDE

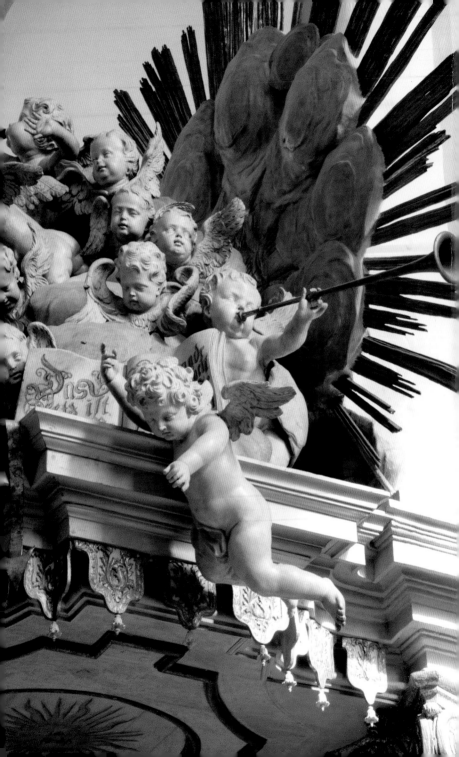

SCHLÜTER IN BERLIN

STADTFÜHRER
A CITY GUIDE

Skulpturensammlung und
Museum für Byzantinische Kunst
Staatliche Museen zu Berlin

HIRMER

Dieser Stadtführer erscheint anlässlich der Ausstellung
This city guide has been published on the occasion of the exhibition

SCHLOSS BAU MEISTER. *Andreas Schlüter und das barocke Berlin*

4. April 2014 bis 13. Juli 2014 | 4 April 2014 to 13 July 2014
Bode-Museum, Skulpturensammlung und Museum für Byzantinische Kunst

Partner | Partners:
Deutsches Historisches Museum, Berliner Dom, Ev. Kirchengemeinde St. Petri – St. Marien,
Stiftung Stadtmuseum Berlin, Stiftung Preußische Schlösser und Gärten Berlin-Brandenburg

Für die Skulpturensammlung und Museum für Byzantinische Kunst – Staatliche Museen zu Berlin herausgegeben
von | Edited for Skulpturensammlung und Museum für Byzantinische Kunst – Staatliche Museen zu Berlin by
Hans-Ulrich Kessler

Koordination bei den Museen | Coordination (museums): Hans-Ulrich Kessler, Claire Guinomet, Diana Fleischer
Publikationsmanagement | Publication management:
Elisabeth Rochau-Shalem, Jürgen Bunkelmann, Sigrid Wollmeiner
Projektleitung | Project management, Hirmer Verlag: Kerstin Ludolph
Projektkoordination | Project coordination, Hirmer Verlag: Jutta Allekotte, Sabine Frohmader
Übersetzung | Translation: Michael Wolfson, Hannover | Hanover
Lektorat | Copy-editing: Uta Barbara Ullrich, Berlin
Korrektorat | Proofreading: Barbara Delius, Berlin
Lektorat Englisch | English copy-editing: Danko Szabó, München | Munich
Gestaltung, Satz und Herstellung | Design, typesetting and production: Sabine Frohmader, Hirmer Verlag
Bildredaktion | Picture editor: Diana Fleischer
Lithographie | Prepress and repro: Reproline Genceller, München | Munich
Druck und Bindung | Printed and bound by: Printer Trento s.r. l., Trient
Papier | Paper: GardaArt Matt 150g

Printed in Italy

© 2014 Staatliche Museen zu Berlin – Preußischer Kulturbesitz, Hirmer Verlag GmbH, München | Munich
und die Autoren | and the authors

Die Deutsche Nationalbibliothek verzeichnet diese Publikation in der Deutschen Nationalbibliographie; detaillierte
bibliografische Daten sind im Internet über http://dnb.de abrufbar. | The Deutsche Nationalbibliothek lists
this publication in the Deutsche Nationalbibliografie; detailed bibliographic data is available on the Internet at
http://dnb.de.

www.smb.museum
www.hirmerverlag.de | www.hirmerpublishers.com

ISBN 978-3-7774-2200-8

Gefördert durch | Sponsored by:

Unterstützt durch | Supported by:

In Kooperation mit | In cooperation with:

INHALT
CONTENTS

EINLEITUNG
INTRODUCTION

Der vorliegende Stadtführer *Schlüter in Berlin* möchte einem an der Kunst und der Geschichte Berlins interessierten Publikum seinen wohl herausragendsten Künstler vorstellen: den Bildhauer und Baumeister Andreas Schlüter (1659/60–1714). Schlüter war ein Barockkünstler par excellence, der schon von seinen Zeitgenossen als der »Michelangelo des Nordens« gepriesen wurde – ein Vergleich, der durchaus nicht zu hoch gegriffen erscheint, war doch der in Danzig geborene Künstler wie sein italienisches Vorbild nicht nur Bildhauer, sondern zugleich Architekt und Entwerfer von komplexen Raumdekorationen, mit denen er der aufstrebenden Residenzstadt an der Spree erstmals europäischen Glanz verlieh.

Auch wenn die Pracht des barocken Berlins und mit ihr die Strukturen des einstigen Stadtzentrums durch Krieg und ideologische Verblendung nunmehr nahezu vollständig ausgelöscht sind, so haben doch wie durch ein Wunder einige der Meisterwerke Schlüters die Zeitspanne von gut 300 Jahren schadlos überdauert. Gewiß, das einst in der Mitte Berlins gelegene Schloß, dessen Umbau und Erweiterung Schlüter von 1699 bis 1706 als Schloßbaudirektor leitete und das den Zweiten Weltkrieg noch vergleichsweise gut überstanden hatte, wurde 1950/51 aus ideologischen Gründen in einem beispiellosen barbarischen Akt auf Geheiß des DDR-Regimes gesprengt und dem Erdboden gleichgemacht. Damit hatte man der Stadt ihr Herz genommen, zugleich war der Bezugspunkt, auf den die Gebäude und Straßen des städtischen Umfeldes ausgerichtet gewesen waren, restlos beseitigt. Führte die erst seit 1647 entstandene Allee Unter den Linden nicht direkt auf das Schloß zu? Und hatte Karl Friedrich Schinkel (1781–1841) mit der streng klassizistischen Kolonnadenfront seines 1830 eröffneten Alten Museums nicht einen genialen Dialog zu Schlüters gleichmäßig rhythmisierter Fassadengliederung des monumentalen Residenzbaus hergestellt? Die gewachsenen Strukturen, die sich einst respektvoll am Bestehenden orientiert hatten, sind verlorengegangen. Nur schwerlich erschließen sich dem heutigen Passanten die räumlichen Bezüge der einstigen barocken Residenzstadt Berlin.

It is the intention of this city guide, *Schlüter in Berlin*, to introduce an audience interested in the art and history of Berlin to the city's perhaps most extraordinary artist: the sculptor and architect Andreas Schlüter (1659/60–1714). Schlüter was a Baroque artist par excellence who was already celebrated by his contemporaries as the 'Michelangelo of the North' – a comparison that by no means seems unrealistic to the extent that the Danzig-born artist was, like his Italian predecessor, not only a sculptor, but also an architect who designed complex interior decorations, lending lustre on a European scale for the first time to the ambitious residence city on the Spree.

Although the splendours of Baroque Berlin along with the structures of the former town centre have been almost completely extinguished as a result of war and ideological delusion, a number of Schlüter's masterpieces have miraculously survived the past three centuries unharmed. Berlin Palace – which once stood in the centre of Berlin, and the rebuilding and expansion of which Schlüter supervised as palace architect from 1699 to 1706 – escaped World War II relatively unscathed. But in 1950/51, the palace was deliberately demolished out of ideological considerations at the behest of the East German regime in an unparalleled act of cultural barbarism. By doing so, the heart of the city was torn out; the reference point on which the buildings and streets in its urban surroundings were oriented was completely eliminated. Is it not the case that the boulevard Unter den Linden, constructed in 1647, led directly to and from the palace? And did Karl Friedrich Schinkel (1781–1841) not enter into an ingenious dialogue with the rhythm of the uniform façade structures from Schlüter's monumental residence architecture in the severe classicistic colonnade of his Altes Museum when it opened in 1830? Structures that developed slowly over time and once respectfully oriented themselves on what had come before have been lost. It is nearly impossible for present-day visitors to fully comprehend the urban spaces and situations that once made up the Baroque residence city of Berlin.

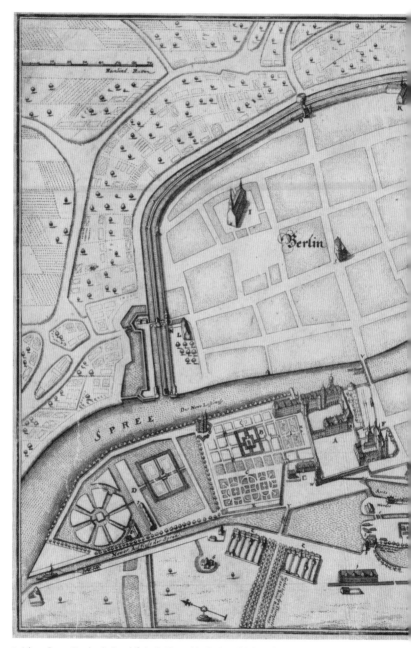

1 Johann Gregor Memhardt, Grundriß der Residenzstädte Berlin und Cölln an der Spree, 1652

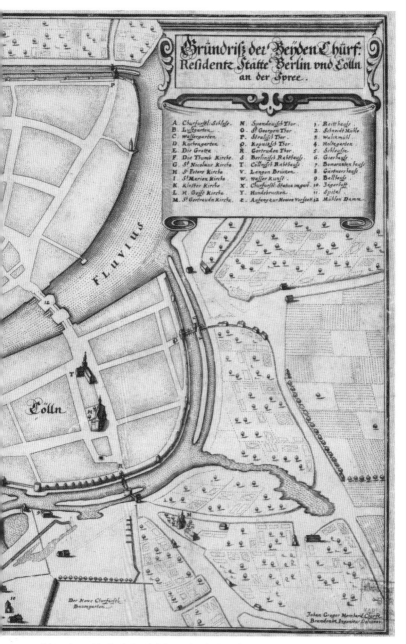

Johann Gregor Memhardt, Grundriß der Beyden Churf. Residenz Stätte Berlin und Cölln an der Spree [Ground plan of the two electorial residence cities of Berlin and Cölln on the Spree], 1652

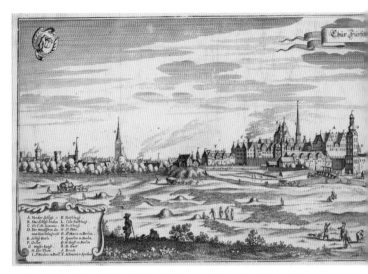

2 Caspar Merian, Blick auf Berlin und Cölln an der Spree von Nordwesten mit Ansicht des Schlosses, 1652

Es ist die Aufgabe des vorliegenden Stadtführers, dem kulturinteressierten Flaneur einen Cicerone an die Hand zu geben, der die städtebaulichen Zusammenhänge anhand der noch existenten Werke Andreas Schlüters veranschaulicht. Dessen Schöpfungen gehören zum Bedeutendsten, was Berlin auf dem Gebiet der Bildhauerkunst vorzuweisen hat. Und dennoch sind diese Meisterwerke nur wenigen bekannt, obwohl sich sogar einige von ihnen am jeweilig angestammten Platz erhalten haben, so etwa die unverrückbaren Schlußsteine mit den »lebensnahen« Köpfen der sogenannten sterbenden Krieger am Zeughaus oder das aufwendig gestaltete Eingangsportal zur Gruft des Hofgoldschmiedes Daniel Männlich d.Ä. und seiner Gemahlin in der Nicolaikirche. Aber auch die barocke Kanzel in der Kirche St. Marien befindet sich noch ebendort, wenngleich aufgrund der veränderten Liturgie zu Beginn des 19. Jahrhunderts an eine andere Stelle verlegt und um 90 Grad gedreht. Andere Bildwerke Schlüters wurden hingegen an einen anderen Standort verbracht, wie das Reiterstandbild des Großen Kurfürsten, das einst in der Sichtachse zum Schloß die Lange Brücke eindrucksvoll beherrschte und nach seiner Evakuierung während des Zweiten Weltkrieges zuzeiten der Teilung Berlins vor das Charlottenburger Schloß transferiert wurde, wo es einen nicht minder ehrenvollen Standort bezog. Hierzu gehört zudem Schlüters Standbild des Kurfürsten und späteren Königs in Preußen Friedrich (1657–1713), das zwar im Original zerstört,

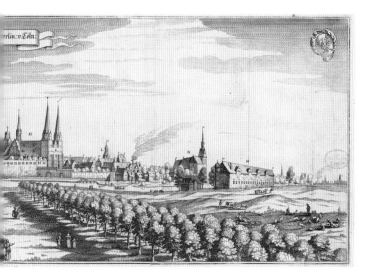

Caspar Merian, Blick auf Berlin von Nordwesten mit Ansicht des Schlosses und des Lustgartens
[View of Berlin from the north-west towards the Palace and Lustgarten], 1652

This city guide serves as a cicerone for the *flâneur* interested in art and culture, presenting the urban contexts by reference to the still existing works of Andreas Schlüter. His creations are among the most important sculptural works ever to be produced in Berlin. And yet few are familiar with these masterpieces, despite the fact that some have survived in their original locations, for example the unalterable keystones on the Zeughaus (Arsenal) with their 'lifelike' heads depicting so-called dying warriors, or the elaborately designed entrance portal to the tomb of court silversmith Daniel Männlich the Elder and his wife in St Nicholas Church. And even the Baroque pulpit in St Mary's Church can still be found there, albeit moved to a different spot and turned by ninety degrees because of liturgical changes in the early 19th century. Other sculptures now occupy different sites, for example the equestrian statue of the Great Elector. It once assumed a prominent position in the sight line of the palace on the Lange Brücke but was later evacuated during World War II and then installed after the division of the city at a no less honourable spot before Charlottenburg Palace. Schlüter's statue of the Elector and future Prussian King Frederick (1657–1713) can also be found here; the original is lost but the copies in Charlottenburg and the Berlin Skulpturensammlung (Sculpture Collection) can still be admired and studied today. And finally there are the sarcophagi in Berlin Cathedral of Frederick and his consort, Queen Sophia

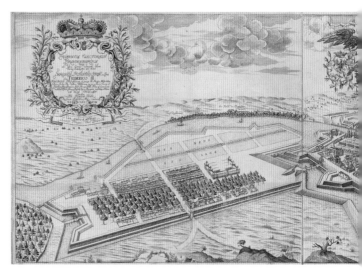

3 Johann Bernhard Schultz, Berlin aus der Vogelschau, um 1688

jedoch durch Kopien vor dem Charlottenburger Schloß und im Bestand der Berliner Skulpturensammlung noch greifbar ist. Schließlich sind auch die Sarkophage von Friedrich und seiner Gemahlin, Königin Sophie Charlotte (1668–1705), im Dom zu nennen, die einst für die Hohenzollern-Gruft der längst verschwundenen Dominikanerkirche bei der Brüderstraße am Schloßplatz geschaffen wurden.

Es war Friedrich, noch als Kurfürst, der die Doppelstadt Berlin-Cölln (Abb. 1–3) in eine Metropole verwandeln wollte, die sich an so altehrwürdigen Städten wie Rom und Paris messen sollte – ein fraglos ambitioniertes Vorhaben, wenn man bedenkt, daß die Stadt nach dem Ende des Dreißigjährigen Krieges gerade einmal 6000 Einwohner zählte, während Paris in dieser Zeit bereits 450.000 Einwohner fasste. Der treibende Impuls für Friedrichs ehrgeizigen Plan war sein Bestreben, die Königskrone zu erlangen – ein Wunsch, der sich am 18. Januar 1701 mit seiner Krönung in Königsberg erfüllen sollte. Repräsentative Bauten und Denkmäler sollten den angestrebten und letztlich erreichten Status allen vor Augen führen. Als Friedrich 1694 Andreas Schlüter vom polnischen Hof König Jan III. Soebieskis in die kurbrandenburgische Residenz berief, engagierte er mit ihm einen Künstler von internationalem Rang, der als Bildhauer wie als Baumeister seine Pläne in die Realität umzusetzen verstand. Es ist diese seltene Symbiose zwischen Auftraggeber und Künstler, die Großes entstehen ließ.

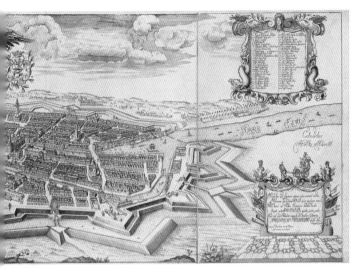

Johann Bernhard Schultz, Berlin aus der Vogelschau [Bird's-eye view of Berlin], c.1688

Charlotte (1668–1705), which were originally made for the Hohenzollern Crypt in the long-vanished Dominican Church near Brüderstraße on Schloßplatz.

It was Frederick who, even as elector, wanted to transform the double city of Berlin-Cölln (figs. 1–3) into a metropolis comparable with such ancient capital cities as Rome and Paris – undoubtedly a very ambitious undertaking when one considers that Berlin had hardly more than 6,000 residents at the end of the Thirty Years' War as compared with the population of Paris at that time, namely 450,000. The driving force behind Frederick's determined plan was his aspiration to royalty – a wish that would be fulfilled on 18 January 1701 with his coronation in Königsberg (the present-day Kaliningrad). Representative buildings and monuments were intended to visibly demonstrate the status he strove for, and ultimately achieved. When Frederick called for Andreas Schlüter to come from the Polish court of King John III Sobieski to the residence of the Electorate of Brandenburg in 1694, he hired an artist of international stature who knew how to make his plans – both as an architect and as a sculptor – become reality. It is this rare symbiosis between patron and artist that made great things possible.

I. WERKE SCHLÜTERS IN BERLIN-MITTE

I. WORKS BY SCHLÜTER IN BERLIN-MITTE

1.

ZEUGHAUS
ZEUGHAUS (ARSENAL)

Unter den Linden 2
(Deutsches Historisches Museum)

Öffnungszeiten:
täglich 10.00–18.00 Uhr

Erbaut 1695–1730

Architekten:
1695 Johann Arnold Nering,
1695–1699 Martin Grünberg,
1698/99 Andreas Schlüter,
1699–1701 Jean de Bodt

Bauplastik:
1696–1699 Andreas Schlüter,
1696–1713 Georg Gottfried
Weihenmeyer,
1700–1713 Guillaume Hulot

Andreas Schlüter und
Georg Gottfried Weihenmeyer
(1666–1715) und Werkstatt

Schlußsteine der Bögen am Erdgeschoß
des Zeughauses
Berlin, 1695–1697, 1706–1709,
nach 1712 Sandstein | H. ca. 140 cm ×
B. ca. 90 cm × T. ca. 40 cm

Johann Jacobi (1661–1726)

Zwölfpfünder *Demminer Rohr*
Berlin, 1706 | Bronze | L. 301 cm,
Kaliber 12,3 cm

Vierundzwanzigpfünder *Albrecht Achilles*
Berlin, 1708 | Bronze | L. 375 cm,
Kaliber 15 cm

Vierundzwanzigpfünder *Geschenk des Kronprinzen*
Berlin, 1708 | Bronze | L. 397 cm,
Kaliber 15,5 cm

An:

Hirmer Verlag GmbH
Nymphenburger Straße 84
80636 München

www.hirmerverlag.de • info@hirmerverlag.de • Tel.: +49-(0)89/121516-0 • Fax: +49-(0)89/121516-10

O Bitte schicken Sie mir regelmäßig Ihr Verlagsprogramm.

O Frau O Herr

Name, Vorname

Straße

PLZ, Ort

Land

O Bitte informieren Sie mich monatlich per E-Mail über Ihre
Neuerscheinungen und Sonderangebote.

E-Mail-Adresse:

oder unter www.hirmerverlag.de/newsletter

Wir freuen uns über Ihre Fragen, Anregungen und Wünsche:

Unter den Linden 2
(Deutsches Historisches Museum)

Opening times:
daily from 10 a.m. to 6 p.m.

Constructed 1695–1730

Architects:
1695 Johann Arnold Nering,
1695–1699 Martin Grünberg,
1698/99 Andreas Schlüter,
1699–1701 Jean de Bodt

Architectural sculpture:
1696–99 Andreas Schlüter,
1696–1713 Georg Gottfried
Weihenmeyer,
1700–13 Guillaume Hulot

Andreas Schlüter and
Georg Gottfried Weihenmeyer
(1666–1715) and workshop
Keystones of the arches on the
ground floor of the Arsenal
Berlin, 1695–97, 1706–09,
after 1712 Sandstone | H. ca. 140 cm ×
W. ca. 90 cm × D. ca. 40 cm

Johann Jacobi (1661–1726)
12-pounder gun *Demminer Rohr*
Berlin, 1706 | Bronze | L. 301 cm,
calibre 12.3 cm

24-pounder long gun *Albrecht
Achilles*
Berlin, 1708 | Bronze | L. 375 cm,
calibre 15 cm

24-pounder long gun *Geschenk
des Kronprinzen*
Berlin, 1708 | Bronze | L. 397 cm,
calibre 15.5 cm

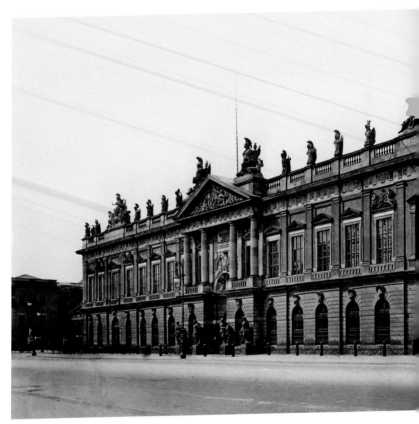

1 Zeughaus, Unter den Linden 2, Aufnahme 1908

Das Zeughaus in Berlin ist nach dem Verlust des Stadtschlosses und neben dem Schloß Charlottenburg der einzige erhaltene monumentale Prachtbau des Hochbarocks in der ehemaligen Residenzstadt und präsentiert zugleich in Teilen seiner Bauplastik das früheste auf uns gekommene Hauptwerk Andreas Schlüters: am Außenbau die Prunkhelme in den Bogenschlußsteinen des Erdgeschosses (Abb. 2) und die Kopftrophäen besiegter Krieger an gleicher Stelle im Innenhof (Abb. 3).

Schon der Große Kurfürst, Friedrich Wilhelm (1620–1688), plante zum Abschluß seiner Stadtbefestigung ein repräsentatives Zeughaus. Für 1683 ist die Existenz eines Holzmodells überliefert, doch wurde erst 1695 unter Kurfürst Friedrich III. (1657–1713) der Grundstein gelegt. Der Plan des Hofarchitekten

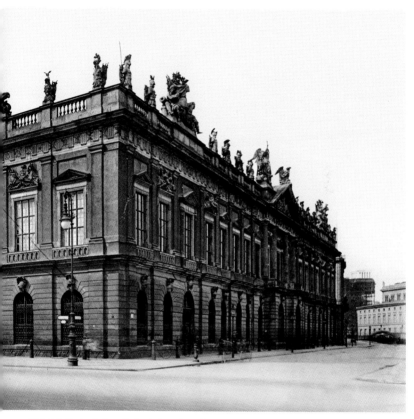

Arsenal, Unter den Linden 2, Berlin, photograph, 1908

After the demolition of the Berlin City Palace, the Zeughaus (Arsenal) and Charlottenburg Palace are the sole remaining examples of representative High Baroque monumental architecture in the former royal capital of Berlin. The Arsenal's architectural sculpture includes at the same time Andreas Schlüter's earliest preserved carved masterpieces: the parade helmets in the keystones on the ground floor of the façade (fig. 2) and the trophy heads of defeated warriors at the equivalent spots in the courtyard (fig. 3).

The Great Elector, Frederick William (1620–1688), had already planned a representative arsenal to complete his city fortifications. The existence of a wooden model is documented for 1683, but the foundation stone was first laid under Elector Frederick III (1657–1713) in 1695. The plan made by court architect Johann Arnold

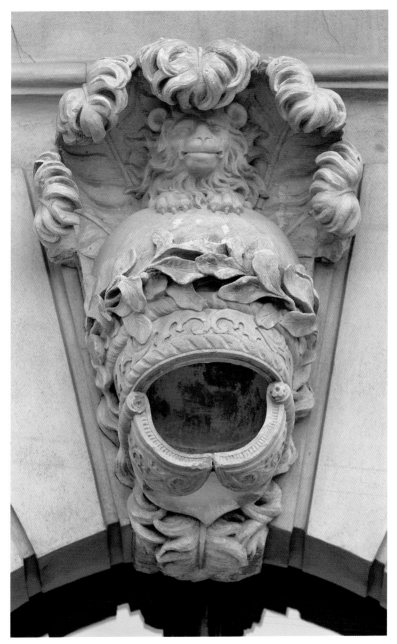

2 Andreas Schlüter, Schlußstein, Prunkhelm mit kauerndem Löwen als Zier, um 1696, Berlin, Zeughaus, Hauptportal
Andreas Schlüter, keystone, parade helmet decorated with cowering lion, c.1696, main portal of Arsenal, Berlin

Nering (1659–1695) called for a free-standing, two-storeyed structure with nineteen axes over a quadratic ground plan around a courtyard. The main floor was to be in the Doric order with arcades over a basement level and a high attic above. This architectonic construction – rhythmised by an avant-corps consisting of three axes emphasising the portal and featuring an extremely wide length with architectural decorations comprising helmets and heads on the keystones, as well as trophies over the windows on the main floor and on the attic – was oriented on Jules Hardouin Mansart's (1646–1708) garden façades for the Palace of Versailles. Even though the proportions were smaller in Berlin and the architectonic ornaments were adapted to the building's specific purpose, the structure nevertheless unmistakably expressed the elector's royal ambitions. The construction work begun according to these plans extended into the 1720s and modifications were made over the course of this long building phase, particularly those introduced by Jean de Bodt (1670–1745), who was named lead architect in 1699, and his sculptor Guillaume Hulot (c.1657–after 1722), to both of whom the building owes its present-day appearance: a gabled middle avant-corps on full-round columns, low balustrade over the main storey and protruding groups of trophies above.

Schlüter was responsible for the realisation of the architectural decorations: on the exterior façade a wide range of seventy-three varied and antique-styled parade helmets arranged in groups of three and ornamented with symbols of victory, all of them extraordinary as regards three-dimensionality and the employment of space. He furthermore created the two shockingly stunning Medusa heads and the thunderbolt of Jupiter surrounded by slain harpies over the portals on the north façade. He similarly made the twenty-two decapitated heads of barbarians affixed in the courtyard as trophies onto shields in addition to two eagles with Jupiter's thunderbolts and two laurel wreaths. The preliminary models were completed in 1696, after which Schlüter and Georg Gottfried Weihenmeyer created the stone sculptures with their assistants in 1696 and 1697.

Severed heads of conquered barbarians form the keystones over the round-arch windows in the courtyard. Opulent beards, wavy hair, draped widths of cloth or belts conceal the wounds to their necks. Their eyes are closed, the mouths are open: these are not 'dying warriors', as they are frequently described – no, heads of the dead are on display. The expressions on the young, middle-aged and older faces still bear the signs of the suffering each and every one of them encountered at the moment of his death. These brilliantly worked out and fashioned facial features in

Johann Arnold Nering (1659–1695) sah einen freistehenden, zweigeschossigen und 19achsigen Baukörper auf quadratischem Grundriß mit Innenhof vor: auf gebändertem Sockelgeschoß mit Arkaden ein dorisch gegliedertes Hauptgeschoß, darüber eine hohe Attika. Dieser architektonische Aufbau, rhythmisiert durch dreiachsige, die Tore hervorhebende Risalite, die extreme Breitenlagerung und der Bauschmuck aus Helmen und Köpfen an den Bogenschlußsteinen sowie Trophäen über den Hauptgeschoßfenstern und auf der Attika waren an Jules Hardouin Mansarts (1646–1708) Gartenfassaden des Versailler Schlosses angelehnt. Damit wurde, wenn auch in der Proportion verkleinert und im architektonischen Ornament der dorischen Ordnung dem Zweck des Hauses angepaßt, die königliche Ambition des Kurfürsten unmißverständlich ausgedrückt. Nach diesem Plan ist der Bau begonnen worden. Im Laufe seiner langen, sich bis ins dritte Jahrzehnt des 18. Jahrhunderts hinziehenden Baugeschichte kam es zu Modifizierungen, vor allem durch den seit 1699 verantwortlichen Architekten Jean de Bodt (1670–1745) und seinen Bildhauer Guillaume Hulot (ca. 1657 – nach 1722), denen der Bau die heutige Erscheinung verdankt: übergiebelter Mittelrisalit auf Vollsäulen, niedrige Balustrade über dem Hauptgeschoß, darüber aufragende Trophäengruppen.

Schlüter hatte den Bauschmuck zu realisieren. Dabei handelte es sich zum einen außen um 73 antikische Prunkhelme, jeweils in Dreiergruppen mannigfach variiert und mit Siegeszeichen geschmückt, von großer Plastizität und voller Raumhaltigkeit hervorragend gearbeitet. Dazu über den Toren der Nordfassade zwei grausig-schöne Medusenhäupter und ein von dahingerafften Harpyen umgebenes Blitzbündel Jupiters. Im Hof zum anderen 22 als Trophäen auf Schilde gebundene Köpfe enthaupteter Barbaren sowie zwei Adler mit den Blitzen Jupiters und zwei Gebinde mit Siegeslaub. Die Modelle, nach denen Schlüter und Georg Gottfried Weihenmeyer mit ihren Gehilfen 1696/97 die Steinskulpturen schufen, waren 1696 fertig.

Abgeschlagene Häupter besiegter Barbaren bilden im Hof den Bogenschluß. Üppige Bärte, gewelltes Haar, drapierte Tücher oder umgehängte Gürtel verdecken die Schnittstellen an den Hälsen. Die Augen sind geschlossen, die Münder offen: Keine »sterbenden Krieger«, wie immer gesagt wird – nein, abgeschlagene Köpfe Getöteter sind ausgestellt. Junge, mittelalte und ältere Gesichter bilden im Ausdruck das jeweilige Erleiden des Todes noch ab. Dieser Ausdruck, in schönster Arbeit bravourös gestaltet, macht, im Verein mit den immer wilden, doch ornamental gelegten Haaren und Bärten, den Eindruck des scheinbar Lebendigen und

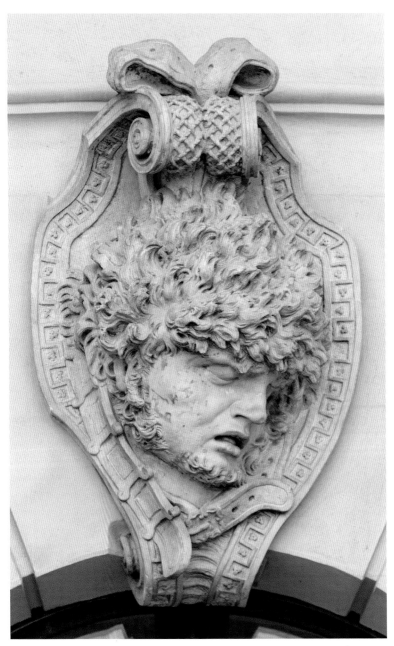

3 Andreas Schlüter, Schlußstein, Kopftrophäe eines besiegten Kriegers, um 1696, Berlin, Zeughaus, Hof
Andreas Schlüter, keystone, head trophy of a defeated warrior, c 1696, Arsenal courtyard, Berlin

gibt den Barbaren im Tod ihre Würde. Schlüter gelang es, in diesen Gesichtern verschiedene Temperamente und Affekte wie Schrecken, Schmerz, Zorn, Verzweiflung und Leiden mit der Schönheit der *exempla doloris* der antiken Kunst – wie *Laokoon*, der *Sterbende Gallier* oder die *Erinnye Ludovisi* – zu verbinden und so dem grauenerregenden Thema eine weit über das Naturalistische hinausgehende Idealität zu verleihen. Die Köpfe gehören zu einem 1696 entwickelten allegorischen Konzept zur Ausstattung des Zeughaushofes, das Schlüters Bronzestatue des Kurfürsten Friedrich III. in der Mitte und vier prunkvolle, nach den Erdteilen benannte Kanonen in den Ecken vorsah. Inmitten der im Hause bewahrten Waffen und Beutestücke sollte der auf einen Schild gehobene Fürst und Feldherr wie ein antiker Imperator als Sieger über Völker aller Zeiten und Erdteile und als Garant des Friedens im eigenen Staat triumphieren. So sind die der Architektur des Arsenals verhafteten Kriegerköpfe auf Kraft und Virtus des Fürsten bezogene Trophäen.

Durch Schlüters 1699 erfolgte Entlassung aus dem Zeughausbau, dessen Leitung er ein Jahr zuvor übernommen hatte, wurde dieses Konzept erst verschleppt und später ganz aufgegeben. Unter seiner Ägide waren neben den Helmen nur die zwölf Schlußsteine der Südhälfte des Hofes entstanden und versetzt worden, die der Nordhälfte wurden aufgrund des stockenden Baufortgangs erst um 1706/1709 ausgeführt, zwar noch nach seinen Modellen, aber nicht mehr unter seiner Aufsicht, und die beiden Schlußsteine an den Treppentürmen datieren gar erst nach 1712.

Zeigt das Zeughaus insgesamt die prachtvolle, an französischer Schloßbaukunst orientierte Architektur Nerings bzw. de Bodts und sein Bauschmuck vom Obergeschoß aufwärts die weithin wirkenden Werke Hulots, so offenbart es dem Nähertretenden in den zur Siegesfeier geschmückten Prunkhelmen außen und den Kopftrophäen des Hofes innen das erste skulpturale Meisterwerk Andreas Schlüters in Berlin in all seiner kunstvollen Ausführung und bildnerischen Schönheit, das zugleich eines der Hauptwerke des nordeuropäischen Barocks darstellt.

combination with the consistently wild and yet ornamentally conceived hair and beards provide the impression of ostensibly living persons and also give dignity at the same time to the barbarian in death. Schlüter succeeded here in combining a variety of temperaments and affects such as horror, pain, wrath, desperation and suffering with the beauty of the *exempla doloris* familiar to us from the art of classical antiquity in such works as the *Laocoön*, the *Dying Galatian* and the so-called *Medusa Ludovisi*, thus lending the blood-curdling subject matter an identity extending far beyond the naturalistic. They belong to an allegorical concept developed in 1696 for the design of the Arsenal courtyard that called for Schlüter's bronze statue of Elector Frederick III in the centre and four magnificent cannons named after the four continents in the corners. Amidst the weapons and spoils of war stored in the building, it was intended that the sovereign and commander be raised on a shield like the imperator of classical antiquity who is triumphant both as the victor over all peoples of all eras and from all corners of the world and as the guarantor of peace and stability in his own land. The warrior heads affixed to the architecture of the Arsenal are accordingly trophies referencing the sovereign's might, bravery and military strength.

As a result of Schlüter's 1699 dismissal from the Arsenal building project, which he had headed since 1698, the realisation of this concept was initially drawn out and later abandoned entirely. Alongside the helmets, only twelve of the keystones for the south half of the courtyard had been carved and set in place. Progress was sluggish and the keystones for the north half were not produced until around 1706–09, still after Schlüter's models but no longer under his personal supervision – and the two keystones for the turret stairs were in fact not even carved until after 1712.

Seen as a whole, the Arsenal is a magnificent example of Nering's and de Bodt's French-oriented palatial architecture, and its sculpture on the upper storey speaks of Guillaume Hulot's far-reaching influence. However, the parade helmets decorated for victory celebrations on the outer façade and the head trophies in the inner courtyard not only represent in all of their skilful execution and artistic beauty Andreas Schlüter's first sculptural masterpiece in Berlin, but are also one of the major works of Baroque art in Northern Europe.

2.
BERLINER DOM
BERLIN CATHEDRAL

Am Lustgarten

Öffnungszeiten:
Montag – Samstag: 9.00–19.00 Uhr
Sonn- und Feiertag: 12.00–19.00 Uhr

Andreas Schlüter und
Johann Jacobi (1661–1726)

Die Prunksärge für Königin Sophie
Charlotte (1668–1705) und König
Friedrich I. (1657–1713)
Berlin, 1705 und 1713 | Zinn, Bronze,
teilweise vergoldet

Am Lustgarten

Opening times:
Mondays to Saturdays, 9 a.m. to 7 p.m.
Sundays and holidays, 12 noon to 7 p.m.

Andreas Schlüter and
Johann Jacobi (1661–1726)

The Sarcophagi for Queen Sophia
Charlotte (1668–1705) and King
Frederick I (1657–1713)
Berlin, 1705 and 1713 | Tin, partially
gilt bronze

1 Berlin, Dom, Aufnahme 1905
Berlin Cathedral, photograph, 1905

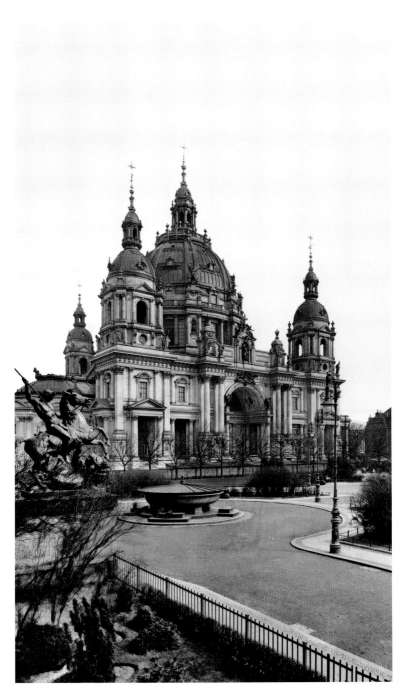

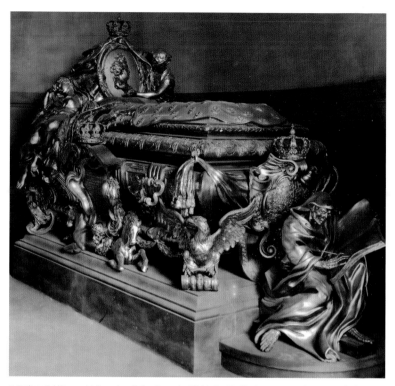

2 Andreas Schlüter und Johann Jacobi, Prunksarg der Königin Sophie Charlotte, 1705, Berlin, Dom, Aufnahme 1892
Andreas Schlüter and Johann Jacobi, sarcophagus of Queen Sophia Charlotte, 1705, Berlin Cathedral, photo, 1892

Im Februar des Jahres 1705 starb überraschend Sophie Charlotte, die zweite Gemahlin des ersten Königs in Preußen. Recht schnell mußte in Berlin, nach Entwurf Andreas Schlüters und gegossen von Johann Jacobi, der für die Beisetzung im Dom vorgesehene Prunksarg geschaffen werden (Abb. 2). Als 1713 Friedrich I. das Zeitliche segnete, wurde im Auftrag Friedrich Wilhelms I. (1688–1740) ein weiterer Sarg angefertigt, deutlich dem bereits vorhandenen ein Pendant gebend, unter Mitwirkung der bereits 1705 erprobten Arbeitsgemeinschaft (Abb. 3). Obwohl fast ein Jahrzehnt Abstand zwischen den beiden Monumenten liegt, sind die Werke als Paar gedacht. Ihr ursprünglicher Standort war die Gruft des »Alten Doms«, der bis zu seinem Abriß im Jahr 1747 an anderer Stelle als der heutige Dom im Umkreis des Berliner Stadtschlosses stand.

In ihren kompositionellen und konstruktiven Grundlagen entsprechen sich die beiden Prunksärge. Sie sind im wesentlichen aus Zinn gearbeitet, nur teilweise

In February 1705, Sophia Charlotte of Hanover, the second consort of the first Prussian king, died suddenly. It became necessary to quickly turn out a sarcophagus for the queen's interment. The design was provided by Andreas Schlüter and it was cast by Johann Jacobi (fig. 2). When Frederick I of Prussia himself shuffled off this mortal coil in 1713, Frederick William I (1688–1740) commissioned another sarcophagus. The consortium that had already proved itself in 1705 was again called upon to produce the new sarcophagus (fig. 3), which clearly formed a counterpart to the existing one. Although the two monuments were produced nearly a decade apart, the works were conceived as a pair. They originally stood in the crypt under the so-called 'Old Cathedral', which was located until its demolition in 1747 not far from the present 'Cathedral' in the vicinity of the City Palace.

The two sarcophagi correspond to each other as far as their compositional and constructive rudiments are concerned. They have for the most part been worked in tin and only partially in bronze, but richly gilded. Both sarcophagi maintain the traditional tub shape with distinct sloping sides and a convex lid of richly profiled tapered decks; they even feature movable carrying handles, as well as rings to open the lid. A royal cloak – replicas of heavy ermine-lined brocades with embroidered crowns – is cast over each of the lids. The sarcophagi have by all means been produced using the traditional materials; tin, often lead as well, were employed for centuries, with the consequence that an ennobling of the royal double burial site was achieved solely by way of form, not via the selection of particularly valuable materials.

The side walls are subdivided into individual sections and the resultant picture fields are filled with bas-reliefs whose depictions reference the monarch entombed within. Allegories dealing with specific female virtues that are particularly appropriate for a queen are to be found on her tomb, while the king's outstanding accomplishments are depicted in the picture fields on his. These scenes, however, are divided up into those dating from the time of his electorate, which are to be found on the left side of the coffin, and those subsequent to his 1701 coronation as king in the East Prussian city of Königsberg (the present-day Kaliningrad) on the right. The coronation itself is included, along with the founding of the university at Halle and the Berlin Academy and Friedrich's qualities as commander-in-chief. Cartouches with extensive inscriptions have been positioned prominently against the reliefs in the centre of the side walls and are carried by heraldic animals: steeds for the House of Hanover, eagles for Prussia. The narrow sides at the foot of the

aus Bronze, jedoch reich vergoldet. Beide wahren die Form des Sarges mit stark geschwungenem Corpus und mehrstufigem, reich profiliertem Deckel; sie besitzen sogar bewegliche Tragegriffe sowie Ringe, um die Deckel anzuheben. Über diese Deckel ist je ein Königsmantel geworfen: Nachbildungen schwerer, hermelingefütterter Brokate mit aufgestickten Kronen. In der Wahl des Materials stehen die Werke in der Tradition eines für Särge üblichen Brauchs – Zinn, häufiger auch Blei, war hierfür über Jahrhunderte in Gebrauch –, die Nobilitierung des königlichen Doppelbegräbnisses erfolgt allein durch die Form, nicht etwa durch die Wahl besonders wertvoller Werkstoffe.

Die Längsseiten sind in einzelne Abschnitte gegliedert. Die so entstehenden Felder tragen Flachreliefs, deren Thematik sich jeweils auf die beigesetzte Person bezieht. Bei der Königin finden sich hier allegorische Hinweise auf spezifisch weibliche Tugenden, die einer Herrscherin besonders angemessen sind; das Begräbnis des Königs zeigt herausragende Taten des Monarchen, eingeteilt in solche aus der Kurfürstenzeit auf der linken Seite des Sarges, auf der rechten solche ab der 1701 vollzogenen Krönung in Königsberg einschließlich derselben, aber auch die Gründungen der Universität in Halle und der Akademie in Berlin sowie Friedrichs Verdienste als Heerführer. In der Mitte der Längsseiten, prononciert vor die Reliefs gesetzt, sind Kartuschen mit ausführlichen Inschriften positioniert, getragen von Wappentieren: Pferde für das Haus Hannover, Adler für Preußen. Die den Fußenden zugeordneten Schmalseiten sind geziert durch eine große Wappenkartusche (am Sarg der Königin) bzw. durch ein Arrangement aus Rüstung und zwei Wappen (am Sarg des Königs). Befestigt sind diese Zutaten an je einer Draperie, deren Enden wiederum durch zwei der Ringe im Sargdeckel laufen. Weitere Wappenkartuschen befinden sich an jenen Schmalseiten, die den Kopfenden zugeordnet sind.

Die Pendantwirkung wird verstärkt durch die Darstellung lebensgroßer Figuren an den Kopf- und den Fußenden der Särge. Am Kopfende sind jeweils zwei weibliche Personifikationen damit beschäftigt, ein mit dem Rahmen auf einem Kissen ruhendes Portraitmedaillon der (respektive des) Verstorbenen gleichzeitig hochkant zu halten und zu bekrönen. Am Fußende des Sarges für Sophie Charlotte hockt der Tod, in ein Buch die Sentenz schreibend: »Sempiternae memoriae Sophiae Carolae Reginae« (»Dem ewigen Gedenken der Königin Sophie Charlotte«); am Fußende des Königssarges kauert die Vergänglichkeit, zu ihrer Linken ein Kind, das seine Augen zu einem schmalen Rohr emporhebt. Da es der Bildhauerkunst, zumindest in Freiplastiken, schwer möglich ist, Seifenblasen

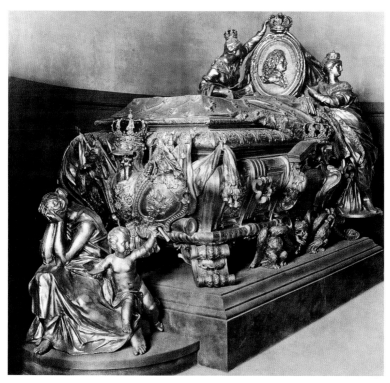

3 Andreas Schlüter und Johann Jacobi, Prunksarg König Friedrichs I., 1713, Berlin, Dom, Aufnahme 1892
Andreas Schlüter and Johann Jacobi, sarcophagus of King Frederick I, 1713, Berlin Cathedral, photograph, 1892

queen's sarcophagus are adorned with a large heraldic cartouche, while armaments and two coats-of-arms have been arranged here on the king's sarcophagus. These additions are each affixed to a piece of drapery, the ends of which in turn run through two of the rings on the lid. Further heraldic cartouches can be found on the narrow sides at the head of the sarcophagus.

The impression that the two sarcophagi were conceived as counterparts is heightened even further by the depiction of life-sized figures at both the head and feet. Two female personifications at each head lift up from a pillow and subsequently crown a framed portrait medallion of the respective deceased monarch. Death squats at the foot of the queen's sarcophagus and inscribes the sentence 'Sempiternae memoriae Sophiae Carolae Reginae' (To the eternal memory of Queen Sophia Charlotte) into a book. Vanitas in turn cowers at the foot of the king's coffin; at the queen's left is a child, who holds up his eyes to a thin tube. Because it is

darzustellen, muß sich der Betrachter vorstellen, die durch das Kind produzierte Blase sei bereits zerplatzt; hierdurch wird der gedankliche Zusammenhang mit Tod und Vergänglichkeit umso stärker intensiviert.

Die Verwendung künstlerisch gestalteter Särge wie für das Haus Hohenzollern war zwar im Berlin des frühen 18. Jahrhunderts nicht grundsätzlich neu. Der besondere Anspruch, wie er sich in den Schlüterschen Entwürfen manifestiert, wird aber augenfällig, vergleicht man diese zum Beispiel mit dem ebenfalls im Dom ausgestellten Sarg für den Großen Kurfürsten (1620–1688). Dieser hat einen glatten, zum Kopfende leicht ansteigenden, kistenartigen Umriß und ist ohne figürlichen Zierrat, einmal abgesehen von den Löwen und den besiegten Kriegern, die als Trägerfiguren dienen. Auch auf den Verstorbenen gibt es keinerlei bildlichen Hinweis. Die Besonderheit der Schlüterschen Invention besteht darin, daß der Künstler zwar einerseits das Erscheinungsbild des Sarges bis in die technischen Details wie Deckel, Ringe und Griffe beibehält, diese aber gleichzeitig künstlerisch und inhaltlich gewissermaßen überwölbt: Schlüter verschränkt die traditionelle Gebrauchsform des Sarges mit Elementen figürlicher Inszenierungen, wie sie sich im Verlauf des 17. Jahrhunderts für das Epitaph, das Grabdenkmal, bewährt hatten.

Das Stilmittel der Verschränkung zweier Formgelegenheiten (*Sarg* und *Epitaph*) zeigt sich in Schlüters künstlerischer Lösung deutlich vor allem in den allegorischen Figuren, die im Sinne eines momentanen, eines transitorischen Aktes die Bildnisse der Verstorbenen aufrecht halten und bekrönen. Im Falle des Königssarges geschieht dies dergestalt, daß sogar eines der Reliefs, die an die Taten Friedrichs I. als Kurfürst erinnern, von der Draperie der Allegorie der Kurmark verdeckt wird und somit nicht zu sehen ist.

Es gibt in der Berliner Domgruft zwei weitere Särge, die immer wieder mit Andreas Schlüter in Zusammenhang gebracht wurden: die letzten Ruhestätten für Philipp Wilhelm Markgraf von Brandenburg-Schwedt (1669–1711, Halbbruder Friedrichs I.) und Prinz Friedrich Ludwig (1707–1708, Sohn Friedrichs I.). Der Sarg des in seinem ersten Lebensjahr verstorbenen Prinzen ist in Details wie der Darstellung des Verstorbenen oder dem Adler am Fußende durchaus auf der Höhe von Schlüters Kunst. Der Sarg Philipp Wilhelms, Johann Georg Glume (1679–1767), einem langjährigen Mitarbeiter Schlüters, zugeschrieben, glänzt mit Insignien der Kriegskunst: Er ruht auf explodierenden Bomben, an seine vertikalen Kanten sind Nachbildungen von Kanonen gesetzt, vier Trophäenreliefs zeigen Waffen und anderes Kriegsgerät, zwei figürliche Reliefs rühmen die Tüchtigkeit des Verstorbenen.

practically impossible to depict soap bubbles in sculpture, particularly in full-round sculpture, the viewer must imagine that the soap bubble has already burst, conceptually intensifying the link between death and the ephemeral ever further.

The use of artistically fashioned sarcophagi was not a fundamentally innovative notion for the House of Hohenzollern in Berlin of the early 18th century. But the exceptional aspirations that manifest themselves in Schlüter's designs become even more obvious when compared, for example, with the sarcophagus of the Great Elector (1620–1688), who is likewise interred in the Cathedral. It has an even, box-like outline with a lid that slopes slightly upwards towards the head and, with the sole exceptions of the lions and the defeated warriors that serve as handles, is without figural decorations. No pictorial reference is made to the deceased. What makes Schlüter's invention special is that while he preserves the appearance of a sarcophagus down to such technical details as lid, rings and handles, they are simultaneously arched over to a certain extent both artistically and as regards contents: Schlüter interlocked the coffin's traditional form of usage with elements of figural configurations that had become standard over the course of the 17th century for the epitaph, the funerary monument.

The stylistic device of interleaving the functions of two divergent objects (coffin and epitaph) can best be seen in Schlüter's artistic solution of having the allegorical figures hold up and crown the portraits of the deceased in the sense of a momentary, a transitory act. In the case of the king's sarcophagus this occurs in such a way that even one of the reliefs commemorating the deeds of Frederick I while elector is covered by the drapery of the allegory of the Kurmark and consequently cannot be seen.

Two further sarcophagi in the crypt of Berlin Cathedral have frequently been mentioned in connection with Andreas Schlüter, namely the final resting places of Philip William, Margrave of Brandenburg-Schwedt (1669–1711, half brother of Frederick I) and Prince Frederick Lewes (1707–1708, son of Frederick I). The sarcophagus of the young prince who died before his first birthday features details – such as the depiction of the deceased and the eagle at the foot – that are by all means comparable with the best of Schlüter's art. Philip William's sarcophagus, attributed to Johann Georg Glume (1679–1767), Schlüter's long-time colleague, gleams with insignias of warfare: it rests on exploding bombs, replicas of cannons are placed at its vertical edges, four trophy reliefs depict armaments and other militaria, while two figural reliefs extol the capabilities of the deceased.

3.
MARIENKIRCHE
ST MARY'S CHURCH

Karl-Liebknecht-Straße 8

Karl-Liebknecht-Straße 8

Öffnungszeiten:
1. April – 30. September:
täglich 10–21 Uhr
1. Oktober – 31. März:
täglich 10–18 Uhr

Opening times:
1 April – 30 September,
daily from 10 a.m. to 9 p.m.
1 October – 31 March,
daily from 10 a.m. to 6 p.m.

Andreas Schlüter

Kanzel

Berlin, 1703 | Eichen- und Nadelholz,
Sandstein, Alabaster, zum Teil vergoldet
und farbig gefaßt

Andreas Schlüter

Pulpit

Berlin, 1703 | Oak and conifer wood,
sandstone, alabaster, partially gilded
and painted

1 St. Marien, Blick von der Rosenstraße, Aufnahme 1911
St Mary's Church, view from Rosenstraße, photograph, 1911

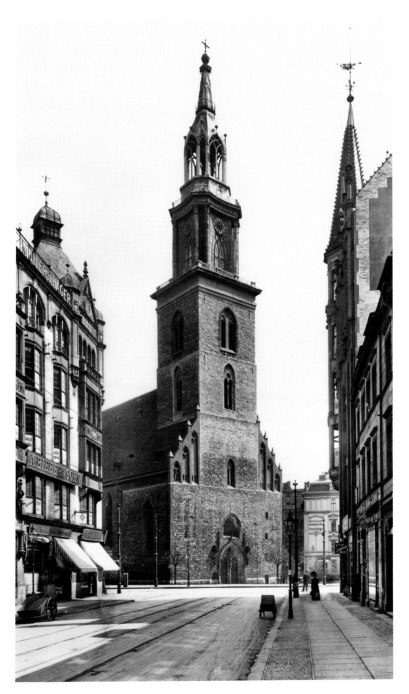

Schlüters Kanzel in der Berliner Marienkirche geht auf eine Stiftung Anna Maria Lehmans zurück, der Witwe des kurfürstlichen Kammersekretärs Georg Friedrich Fehr, welche zu ihrem und ihres Mannes Gedenken den Bau der Anlage veranlaßte. Die Kanzel, 1703 vollendet, stellt in verschiedener Hinsicht ein besonderes Werk dar. Bekannt wurde sie vor allem durch die Art ihrer Aufstellung: Unter großem technischen Aufwand wurde der zweite nördliche Pfeiler in Höhe von 6,5 m durchtrennt und durch den Kanzelbau unterfahren. Dieser besteht aus vier ionischen, durch Eisenklammern miteinander verbundenen Sandsteinsäulen, an denen der Kanzelcorpus auf dieselbe Weise befestigt ist, ebenso wie der Schalldeckel an der Deckplatte. Hierbei werden die Gewichte von Kanzelkorb und Schalldeckel durch die Drucklast des restlichen Pfeilers gehalten, der sich nach oben um weitere 5 m fortsetzt. Dieses statische Wagnis wurde von den Zeitgenossen vielfach bewundert, doch schon bald hatte sich das Wissen darum, wie der durchtrennte Pfeiler technisch abgestützt worden war, verloren.

In der mittelalterlichen Hallenkirche, seit 1539 lutherisch, bildete die Kanzel neben dem Hochaltar einen von zwei liturgischen Schwerpunkten im Kirchenraum, da lutherische Gemeinden – im Gegensatz zu reformierten Kirchen – die Messe beibehielten und die traditionellen Standorte von Hochaltar und Kanzel übernahmen (Abb. 2). Erst 1949 wurde die Kanzel an ihren heutigen Standort verlegt, den letzten freistehenden nördlichen Pfeiler, wobei sie – dem ursprünglichen Aufstellungsort entsprechend – in die Stütze eingebaut wurde (Abb. 3). Hierbei änderte man jedoch ihre Ausrichtung um 90 Grad, so daß der eintretende Besucher die Kanzel nun nicht mehr seitlich, sondern von der Vorderseite her wahrnimmt.

Der Kanzelcorpus besteht aus einem hölzernen, vollständig mit Alabaster verkleideten Kern und wird von flankierenden lebensgroßen Engeln mittels federnder Voluten scheinbar schwebend emporgehalten. Er ist über polygonalem Grundriß angelegt und weist eine reiche skulpturale Ausstattung auf, zu der drei Reliefs mit den Darstellungen von Caritas, Spes und dem predigenden Johannes d. T. zählen. Bekrönt wird die Anlage von einem hölzernen Schalldeckel mit einer bewegten, pyramidal angeordneten Gruppe jubilierender Engel in einer Wolkengloriole. Auf der linken Seite werden die Gesetzestafeln Mose von einem Engel gehalten, auf der rechten präsentiert ein weiterer ein aufgeschlagenes Buch mit dem Vers 1,17 aus dem Johannesevangelium: »Denn das Gesetz ist durch Mose gegeben, die Gnade und die Wahrheit ist durch Jesum Christum worden.«

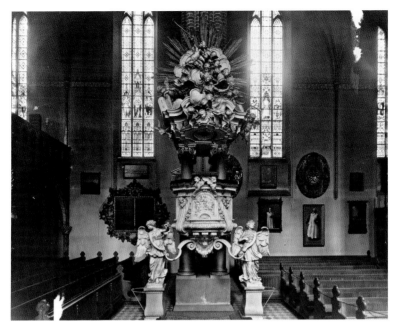

Andrea Schlüter's pulpit in St Mary's Church, Berlin, has its origins in a bequest made by Anna Maria Lehman in memory of herself and her late husband, the electoral chamber secretary Georg Friedrich Fehr. The pulpit, completed in 1703, is a very special work in several respects. It became well known primarily as a result of the way it was installed. Requiring a major technical effort, the second north pillar was initially severed 6.5 metres off the ground and then the pulpit structure was shifted into place underneath. The pulpit as a whole consists of four Ionic sandstone columns connected to each other with iron braces on which the enclosed pulpit platform and the sounding board on the cover panel were attached using the same method. In the process, the weight of the pulpit proper and the sounding board are carried by the compression load of the residual pillar that continues upwards for a further five metres. The knowledge about how the risky architectural feat of supporting the separated pillar was accomplished – a measure that was already much admired by contemporaries – was soon lost.

Along with the high altar, the pulpit was one of the two liturgical focal points in the medieval hall church, which has been Lutheran since 1539, to the extent that

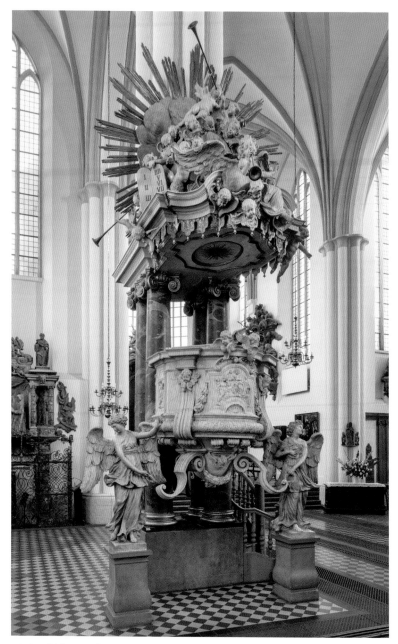

3 Andreas Schlüter, Kanzel, 1703, Berlin, St. Marien, heutiger Standort

Andreas Schlüter, pulpit, 1703, St Mary's Church, Berlin, present location

Lutheran congregations, as opposed to other reformed churches, retained the mass and the traditional locations of high altar and pulpit within the church (fig. 2). The pulpit was transferred to its present site, the last free-standing north pier, in 1949, whereby it was fitted into the support in correspondence with its original installation (fig. 3). By doing so, however, its alignment was shifted by ninety degrees, meaning that visitors entering the church now no longer perceive the pulpit from the side but from the front.

The pulpit's raised enclosed platform consists of a wooden core that is completely lined with alabaster and seemingly held aloft by the flanking life-sized angels by means of flexible volutes. It is arranged over a polygonal ground plan and features a rich sculptural programme that includes three reliefs with depictions of the virtues of charity and hope and of John the Baptist preaching. The structure is crowned by a wooden sounding board with a moving, pyramidally arranged group of jubilant angels in an aureole. The tablets of the Ten Commandments are held by an angel on the left, while a book on the right is opened to the Gospel according to John, verse 1:17: 'For the law was given by Moses, but grace and truth came by Jesus Christ.'

The inspiration of Italian models that Schlüter could have studied during his 1696 trip there is clearly evident in the structure's overall concept, as well as in the design of some of the individual figures. Two works by Gian Lorenzo Bernini (1598–1680) in particular, the *Cathedra Petri* (fig. 4) and the *Baldacchino* in St Peter's Basilica, Rome, play a noticeably influential role. Both works are closely connected to the veneration of St Peter: while the baldachin is situated over the traditional location of the apostle's tomb, the *Cathedra Petri*, a monumental replica of a throne, contains the ivory-decorated wooden chair that, according to a long tradition, was revered as the bishop's chair of the first apostle. Schlüter borrowed several significant features from the *Cathedra Petri* for his structure, which encompasses a liturgical furnishing that seemingly descends from above and which is carried by supporting figures with volutes and crowned by an aureole of angels and a corona. Bernini's baldachin is similarly conceived; its cornice is formed by volutes carried on bands by four angels. It is possible that Schlüter was also familiar with Bernini's first baldachin project from 1626, in which the holding motif was expressed differently and much more categorically than in the completed work. Bernini's influence can furthermore be seen in the poses of Schlüter's angels and the structures of their faces. It may seem surprising at first glance that Bernini's *Cathedra Petri* – a work that is intimately tied to the emotionalism of the Counter-Reformation and the self-conception of

Die Gesamtkonzeption der Anlage sowie auch die Gestaltung einzelner Figuren läßt deutlich den Einfluß italienischer Vorbilder erkennen, die Schlüter während seines Italienaufenthalts 1696 vor Ort studieren konnte. Hierbei zeigt sich insbesondere eine Rezeption von zwei Werken Gianlorenzo Berninis (1598–1680), der *Cathedra Petri* (Abb. 4) und dem Baldachin in der römischen Peterskirche. Beide Anlagen stehen in engster Verbindung mit der Verehrung des hl. Petrus: Während sich der Baldachin oberhalb des vermuteten Apostelgrabes befindet, beinhaltet die als *Cathedra Petri* bezeichnete monumentale Thronnachbildung eine Reliquie in Form eines hölzernen, mit Elfenbein dekorierten Stuhls, der über einen langen Zeitraum hinweg als Bischofsstuhl des ersten Apostels angesehen wurde. Von der *Cathedra Petri* übernahm Schlüter wesentliche Merkmale des Aufbaus, bestehend aus einem scheinbar herabschwebenden liturgischen Ausstattungsstück, das von Trägerfiguren mittels Voluten gestützt und von einer Engelsgloriole mit Strahlenkranz bekrönt wird. Ähnlich gestaltet ist Berninis Baldachin, dessen durch Voluten gebildete Bekrönung von vier Engeln an Bändern gehalten wird. Möglicherweise war Schlüter auch Berninis erstes Baldachinprojekt aus dem Jahr 1626 bekannt, welches das Motiv des Emporhaltens durch die Engel in anderer Form und viel dezidierter als im ausgeführten Werk zum Ausdruck bringt. Darüber hinaus zeigt sich berninesker Einfluß in den Posen der Schlüterschen Engel sowie in der Gestaltung ihrer Gesichter. Die für eine lutherische Kirche zunächst überraschend erscheinende Rezeption von Berninis *Cathedra Petri* – einem Werk, das auf das Engste mit gegenreformatorischem Pathos und dem Selbstverständnis der katholischen Kirche verbunden ist – erfuhr in der Schlüterschen Kanzel eine dem Protestantismus angemessene Umdeutung. Während Berninis *Cathedra* mit »der Übergabe der Schlüsselgewalt von Christus an Petrus« und dadurch mit dem Primat des römischen Papsttums assoziiert wurde, ist es hier die Kanzel als Ort der Predigt, die vom Himmel herabschwebt und im wörtlichen wie im figurativen Sinn als Pfeiler der Kirche anzusehen ist. Dies entspricht der auf Luther zurückgehenden Auffassung, daß die Autorität der Schrift über der Autorität der menschlichen Leiterschaft stehe.

the Catholic Church – was apparently quoted in a Lutheran church, but Schlüter's pulpit reinterprets it in keeping with Protestant teachings. While Bernini's *Cathedra* is associated with Christ giving the keys to Peter and consequently with the primacy of the Bishop of Rome, it is the pulpit as the site where sermons are preached that descends from heaven and which is to be seen both literally and figuratively as a pillar of the church. This corresponds to the approach first taken by Luther, that the authority of Scriptures stands above the authority of human leadership.

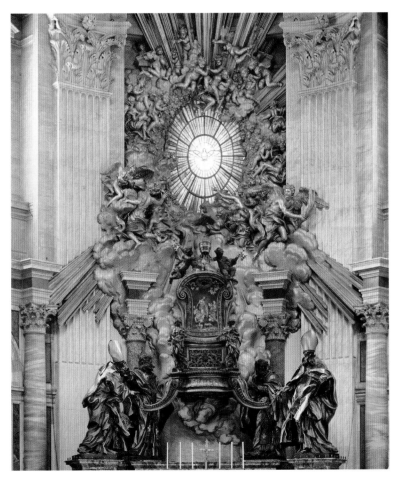

4 Gianlorenzo Bernini, Cathedra Petri, 1657–1666, Rom, St. Peter
Gianlorenzo Bernini, Cathedra Petri, 1657–66, St Peter's Basilica, Rome

4.
NIKOLAIKIRCHE
ST NICHOLAS CHURCH

Nikolaikirchplatz

Nikolaikirchplatz

Öffnungszeiten:
täglich 10.00–18.00 Uhr

Opening times:
daily from 10 a.m. to 6 p.m.

Andreas Schlüter

Grabmal Daniel Männlichs d.Ä.
(1625–1701)
Berlin, 1699/1700 | Portalöffnung:
H. 207 cm × B. 110,5 cm × T. 20 cm |
Gruft· H. 286 cm × B. 215 cm × T. 245 cm

Andreas Schlüter

Tomb of Daniel Männlich the Elder
(1625–1701)
Berlin, 1699/1700 | Portal opening:
H. 207 cm × W. 110.5 cm × D. 20 cm |
Crypt: H. 286 cm × W. 215 cm × D. 245 cm

1 St. Nikolai, Blick von Südwesten, Aufnahme 1939
St Nicholas Church, view from the south-west, photograph, 1939

Unter den zahlreichen Grabmonumenten Berlins und Brandenburgs ist Andreas Schlüters Grabmal für den Hofgoldschmied Daniel Männlich d.Ä. (1625–1701) und seine Frau Anna Katharina Fritz (1636–1698) eine sehenswerte Ausnahmeerscheinung (Abb. 2). Im Vergleich mit der nordeuropäischen Grabmalskunst um 1700 geht vom Männlich-Grabmal eine starke Signalwirkung aus, die sich nicht aus besonderer Größe oder materiellem Überfluß speist, sondern aus formalästhetischen und ikonographischen Besonderheiten in zurückhaltender räumlicher Ausdehnung an der westlichen Innenwand der Nikolaikirche, der neben St. Marien zweiten Hauptkirche Berlins. Es ist an sich kein Grabmal. Vielmehr umspielen Architektur und Figurenensemble den Eingang zur Männlich-Gruft, wobei die Gruft selbst heute nicht mehr erhalten ist. Das Grabmal und sein Ort, die Nikolaikirche, ein »Pantheon Berliner Geschlechter«, sind für die Männlichs eine hohe künstlerische Auszeichnung, die um 1700 für Hofgoldschmiede nicht üblich war.

Schlüters Portalausstattung gliedert sich deutlich in eine untere Architektur- und eine obere Figurenzone. Unten wird der dreifach geschichtete Türrahmen von den rustikalen Pfosten der vordersten Schicht geprägt. Sie wachsen mit einer leichten Innenneigung schräg empor und verleihen der Türrahmung jene kühle Anmut, die auf den Portaltypus der archaischen und dorischen Begräbnisstätten oder Tempelportale zurückgeht. Ungleich festlicher und variationsreicher erscheint dann der obere Bereich des Grabmals. In das Gebälk über den Pfosten drängt sich die Inschriftenkartusche, die durch das Spalten des Architravs zentrale Bedeutung reklamiert und die ganze Aufmerksamkeit auf den Inschriftentext lenkt, der Männlich als Hofgoldschmied, Altmeister seiner Zunft und Vater von zwölf Kindern vorstellt. Darüber findet das Figurenschauspiel statt (Abb. 3): Der mumifizierte Tod lagert als Riese über die gesamte Breite des Monuments auf dem Gebälk und greift links nach dem mit erhobenen Armen fliehenden Kleinkind, während rechts ein Knabe mit schreckhaftem Abwehrgestus das tödliche Schauspiel beobachtet. Die Mittelachse der Supraporta wird durch die beiden zentralen Voluten des geteilten Gesimses fixiert und gipfelt in der großen Urne darüber, an deren Vorderseite mittig das reliefierte Doppelportrait des Ehepaares Männlich im Profil zu sehen ist, flankiert von zwei Genien, die sich mit pathetischem Schwung in das hinterfangende Tuch drehen. Nicht umsonst blicken die Männlichs nach rechts, vom tödlichen Schauspiel ab- und offensichtlich einem neuen Leben nach dem Tod zugewandt. Allein ihr scharf geschnittenes, feines Profilportrait

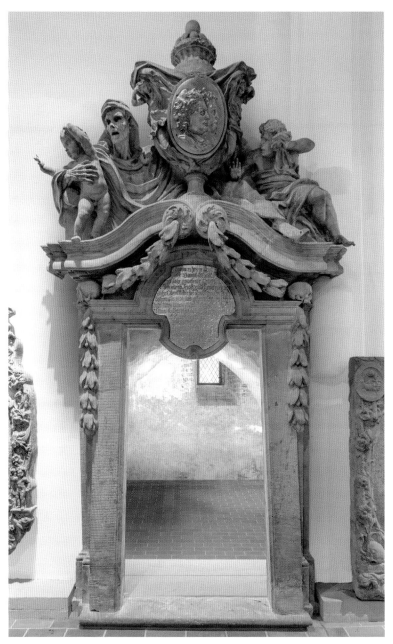

2 Andreas Schlüter, Grabmal Männlich, 1699/1700, Berlin, St. Nikolai
Andreas Schlüter, Männlich tomb, 1699/1700, St Nicholas Church, Berlin

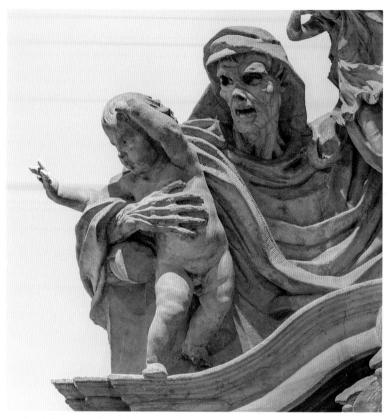

3 Andreas Schlüter, Grabmal Männlich (Detail), 1699/1700, Berlin, St. Nikolai
Andreas Schlüter, Männlich tomb (detail), 1699/1700, St Nicholas Church, Berlin

in ursprünglich vergoldeter Bronze (1988 rekonstruiert in vergoldetem Stuck) ist zu dieser Zeit am Grabmal besonders ungewohnt. Tuch und Medaillon rücken die überdimensionale Urne als Todes- und Grablegesymbol anschaulich in den Hintergrund, da sie das Aschegefäß fast vollständig verbergen, nur sein Deckel ragt oben heraus wie eine Krone, die das Doppelbildnis zusätzlich betont, während sein Fuß wie der Sockel des Medaillons erscheint. Die Verdeckung der Urne und ihr förmlicher Ersatz durch das Medaillon müssen wie eine Metamorphose gelesen werden, als Verwandlung der sterblichen Überreste in der Urne in die Auferstehung der Verstorbenen im Portrait. Der Eindruck verstärkt sich durch das Lagern der Todesfigur, deren Zentrum der Schoß ist, aus dem die Urne und vor allem das Doppelportrait der Männlichs emporwächst. Das *memento mori* als

Of all the numerous funerary monuments preserved in Berlin and Brandenburg, Andreas Schlüter's tomb for court goldsmith Daniel Männlich (1625–1701) and his wife, Anna Katharina Fritz (1636–1698), is one of the most exceptional (fig. 2). Compared with sepulchral art in Northern Europe from around 1700, the Männlich tomb has a strong, eye-catching effect that is founded not on size or material opulence, but rather on the formal aesthetic qualities and particular iconographic features of this modestly dimensioned work on the west interior wall of St Nicholas Church, Berlin's second main church after St Mary's. In principle, it is in fact not a tomb. Architecture and figural ensembles swirl instead around the entrance to the Männlich crypt, which itself has not been preserved. The tomb and its location in St Nicholas Church, a 'pantheon of noble Berlin families', represents a high artistic accolade for the Männlichs that was uncommon for court goldsmiths around 1700.

The decorative scheme of Andreas Schlüter's portal is clearly structured in an architectural zone at the bottom and a figural zone at the top. The threefold-layered door frame is characterised by the archaic jambs of the forwardmost layer. They rise upwards with a slight inward slant, lending the door frame a reserved graceful quality that can be traced back to the portal type of Archaic and Doric burial sites or temple portals. The upper section of the tomb makes a much more ceremonious and richly varied impression. The inscription cartouche thrusts itself into the lintel over the door jambs, laying claim to be of central importance by means of the gap in the architrave, causing the viewer to focus his attention on the text of the inscription that describes Männlich as court goldsmith, doyen of his guild and father of twelve children. A figural spectacle takes place above the text (fig. 3): the mummified personification of death reclines as a colossus on the lintel across the entire width of the monument and reaches out to his right after a small child who attempts to flee with upraised arms. At the same time, a frightened little boy who tries to avert danger from himself with his arms observes the deadly pageant from the other side. The middle axis of the sopraporte is fixed by the two central volutes of the divided cornice, culminating in the large urn that features a relief portrait of the couple in profile on the front. The couple is flanked by two genii that twist themselves with dramatic vigour into the widths of material at their backs. It is not for nothing that the Männlichs are looking off to their left, away from the deadly spectacle and ahead towards a new life after death. Even the fine, sharply focused profile portraits of the Männlichs (originally gilt bronze,

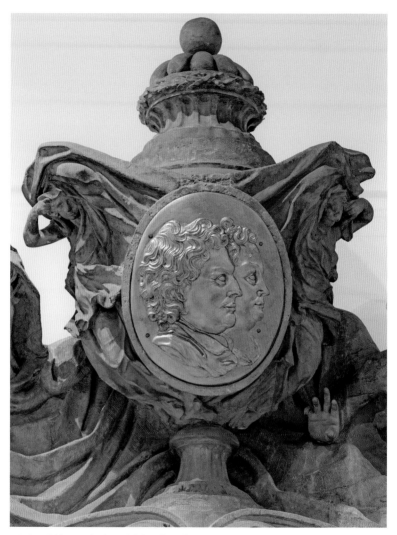

4 Andreas Schlüter, Grabmal Männlich (Detail), 1699/1700, Berlin, St. Nikolai
Andreas Schlüter, Männlich tomb (detail), 1699/1700, St Nicholas Church, Berlin

düstere Vergänglichkeitsdoktrin erfährt in diesem Phönix-aus-der-Asche-Motiv die positive Umdeutung im Sinne der unsterblichen Präsenz der Männlichs, die den Tod überwunden zu haben scheinen.

reconstructed in gilt stucco in 1988) are quite unusual on sepulchral monuments of the time. The fabric and medallion cause the over-sized urn symbolising death and burial to unequivocally fade into the background because they almost completely conceal the funerary vessel. Only the lid protrudes upwards like a crown, emphasising the double portrait even further, while the foot appears like the base of the medallion. The concealing of the urn and its formal replacement by the medallion must be read as a metamorphosis, as the transformation of the mortal remains in the urn into the resurrection of the dead depicted in the portrait. This impression is heightened even further by the reclining position of the figure of death, at whose centre is the womb from whence the urn and especially the double portrait of the Männlichs ascend upwards. Instead of being an ominous doctrine of transience, the memento mori here undergoes a positive reinterpretation through the motif of the 'phoenix rising from the ashes' in the sense of the immortal presence of the Männlichs, who have seemingly been victorious over death.

5.
BERLINER SCHLOSS
BERLIN CITY PALACE

Schloßplatz

Erbaut 1443–1716

Bauleitung Andreas Schlüter:
1698–1706

Bau der Kuppel 1845–1853
Sprengung 1950/51
Neubau seit 2013

Schloßplatz

Built 1443–1716

Construction supervision by
Andreas Schlüter: 1698–1706

Dome built 1845–53
Demolished 1950/51
Ongoing reconstruction since 2013

1 Berliner Schloss, Portal V der Lustgartenfassade
Berlin City Palace, portal V of the Lustgarten façade

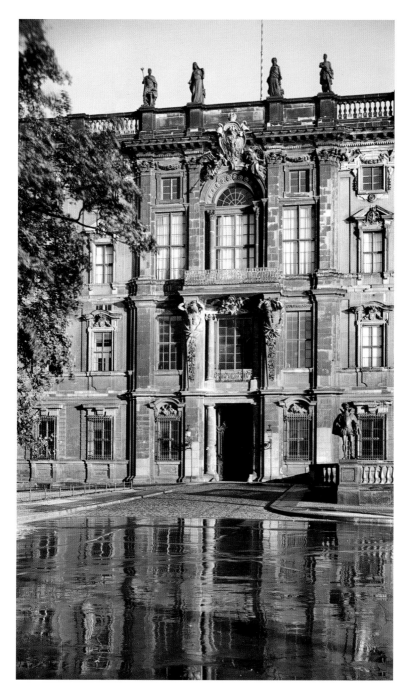

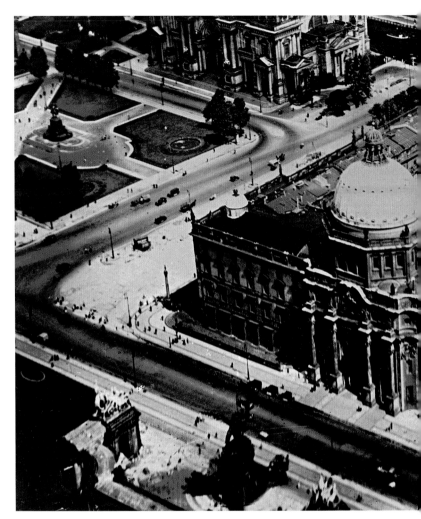

2 Berliner Schloß, Luftaufnahme 1914

Nachdem Kurfürst Friedrich III. (1657–1713) 1688 die Regierung übernommen hatte, geriet auch das Berliner Schloß in den Fokus seiner Baupolitik. Dies ist verständlich, bildete das Gebäude damals doch ein Konglomerat einzelner Bautrakte, die größtenteils im 16. Jahrhundert entstanden waren. 1690 begann Johann Arnold Nering (1659–1695), der bedeutendste Berliner Barockbaumeister vor Andreas Schlüter, im südöstlichen Bereich des Innenhofes einen

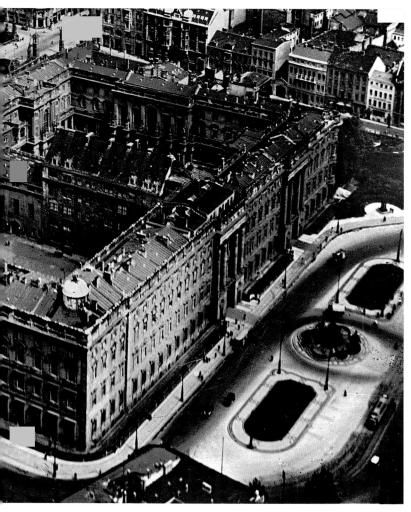

Berlin City Palace, aerial photograph, 1914

When Frederick III (1657–1713) became Elector of Brandenburg in 1688, he increasingly focused his building activities on the Berlin City Palace. This is understandable to the extent that the structure was at that time largely a conglomeration of separate tracts that had been erected in the 16th century. In 1690, Johann Arnold Nering (1659–1695), the most important Berlin Baroque architect before Andreas Schlüter, began construction work on a two-storeyed arcade in the

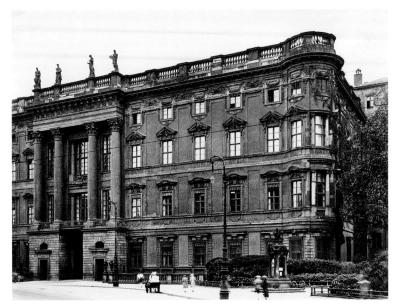

3 Berliner Schloß, Fassade zum Schloßplatz mit Portal I, historische Aufnahme
Berlin City Palace, façade facing Schloßplatz with portal I, historic photograph

zweigeschossigen Laubengang anzulegen, dem korinthische Kolossalsäulen vorgesetzt waren. Nichts deutet allerdings darauf hin, daß diese Galerie den gesamten Hof umziehen sollte, wie sich überhaupt für die damalige Zeit kein schlüssiges Modernisierungskonzept erkennen läßt. Nach Nerings frühem Tod 1695 übernahm vorübergehend Martin Grünberg (1655–1706) die Bauleitung. 1697 und 1698 suchte der Hof erfolglos nach versierten auswärtigen Architekten. In dieser Situation erkannte Schlüter seine Chance. Er offerierte 1698 ein Modell, das vorsah, die älteren Flügel nicht abzureißen, sondern lediglich zu einem homogenen Kubus umzuformen, dann aber vor allem die Fassaden radikal zu erneuern. Diese Idee überzeugte den Hof und sicherte Schlüter den Auftrag.

Im Herbst 1698 begann der Umbau, ein Jahr später wurde Schlüter zum Schloßbaudirektor ernannt. Schon anläßlich des Einzugs Friedrichs I. (III.) in Berlin am 6. Mai 1701 nach seiner Krönung zum König in Preußen war die Renovierung der zum Schloßplatz gerichteten Fassade vollendet (Abb. 3). Schlüter griff zwar die drei Geschosse des Altbaus auf, ersetzte jedoch die Giebelaufbauten durch ein Halbgeschoß und eine umlaufende Dachbalustrade. Großen Wert legte

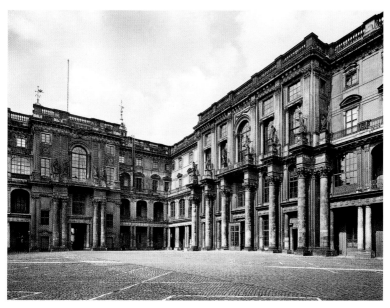

4 Berliner Schloß, Kleiner Schloßhof mit Hofportal V (links) und Risalit des Großen Treppenhauses (rechts), historische Aufnahme
Berlin City Palace, small palace courtyard with court portal V (left) and risalit of the great staircase (right), historic photograph

south-east section of the courtyard with Corinthian columns in the colossal order placed before them. Nothing suggests, however, that this gallery was intended to be extended around the entire courtyard, just as no coherent modernisation concept at all is recognisable at that time. After Nering's early death in 1695, construction work was supervised on a temporary basis by Martin Grünberg (1655–1706). In 1697 and 1698, the court looked in vain for an experienced outside architect. Schlüter saw an opportunity for himself in this situation and presented a model in 1698 that did not call for demolishing the older wings but rather reshaping them into in a homogeneous cube, after which a radical renovation of the façade would be commenced with. The court was convinced by this idea, assuring Schlüter the commission.

Working on rebuilding the palace was begun in the autumn of 1698 and Schlüter was named supervisor of the royal buildings a year later. The renovation of the façade facing the Schloßplatz was already completed in time for the patron's arrival in Berlin on 6 May 1701 after his coronation as King Frederick I of Prussia (fig. 3). Schlüter took up the structure's three storeys, but he replaced

er auf die bauplastische Ausstattung, die beredten Ausdruck in den Fenstergiebeln oder den fast vollplastisch gearbeiteten Adlern der oberen Frieszone fand. Den Hauptakzent setzte in der Mitte der triumphbogenartige Portalrisalit, dessen kolossale Freisäulen auf mächtigen Sockelblöcken ruhten, während die dahinterliegende Wand weitgehend in Fensterflächen aufgelöst war. Seitlich wurde die Fassade durch Eckrondelle begrenzt, die im Kern noch die älteren Renaissance-Erker enthielten.

Der gegenüberliegende Trakt zum Lustgarten mußte erst aufgestockt werden, um den Hof allseitig zu umschließen und nach außen ebenfalls eine repräsentative Fassade anzulegen, was bis 1702 geschah. Parallel arbeitete Schlüter am Innenhof, wo er anfangs die von Nering entwickelte Kolossalordnung aufgegriffen hatte. Zugunsten einer ästhetisch überzeugenderen, zweigeschossigen Lösung mit gekuppelten dorischen Säulchen im Erdgeschoß (Abb. 4) gab Schlüter jedoch diese Planung auf und ließ die bereits errichteten Kolossalsäulen entfernen. Bis 1706 zogen sich die Arbeiten an den Hofgalerien hin, die die seitlichen Hofportale mit dem gegen 1704 vollendeten Portal des Großen Treppenhauses verbanden, das den Höhepunkt der Hofarchitektur bildete und in die königlichen Gemächer führte, deren bis 1706 erfolgte Inneneinrichtung ebenfalls gänzlich von Schlüter stammte (Abb. 5, 6). Außerdem war er ab 1701 mit der Modernisierung und Erhöhung des Münzturms auf knapp 100 m beauftragt. Daß der Turm im Sommer 1706 wegen statischer Schwierigkeiten bei einer Höhe von etwa 60 m wieder abgetragen werden mußte, kostete ihn sein Amt.

Ihm folgte Johann Friedrich Eosander von Göthe (1669–1728), der nicht etwa Schlüters Modell ausführte, sondern vielmehr das Schloß nach Westen verdoppelte. 1716 hatte der Bau im Äußeren seine endgültige Gestalt erreicht, bis auf die Kuppel, die erst um 1850 hinzukam. Im Zweiten Weltkrieg brannte das Schloß aus, die Ruine wurde 1950/51 gesprengt. Derzeit erfolgt im Rahmen der Errichtung des Humboldtforums die Rekonstruktion der barocken Außenfassaden und des von Schlüter geschaffenen Innenhofes.

Entstehung und Bedeutung des Berliner Schlosses sind eng mit der Geschichte Brandenburg-Preußens verknüpft. Womöglich war es das hervorragendste Gebäude, das dieser Staat je hervorgebracht hat. Das barocke Schloß gehörte zu den wichtigsten europäischen Residenzbauten seiner Zeit und stand auf einer Stufe mit dem Pariser Louvre und dem Stockholmer Schloß; im Heiligen Römischen Reich Deutscher Nation war es zu Beginn des 18. Jahrhunderts

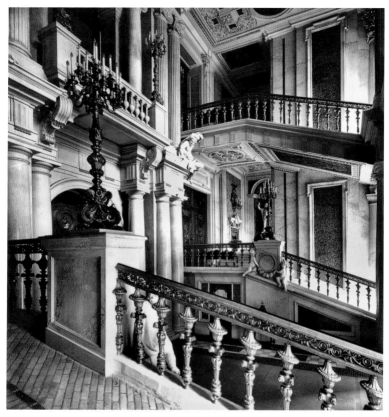

the pediments with a mezzanine and a circumferential roof balustrade. He placed great importance on the architectural sculptures, which found eloquent expression in the window pediments and the nearly full-round eagles on the upper frieze zone. The main accent was placed in the centre of the triumphal arch-like avant-corps portal, whose colossal free-standing columns rested on powerful bases, while the wall they stood against was largely taken up by windows. The façade was delimited at the sides by corner turrets, which encompassed the older Renaissance bays in their cores.

The height of the opposite tract facing the Lustgarten first had to be increased in order to enclose the courtyard on all sides and to construct a representative façade, which was completed in 1702. Schlüter worked in parallel on the courtyard,

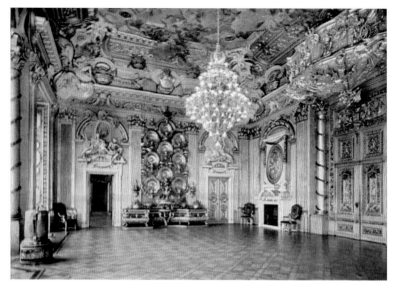

6 Berliner Schloss, Rittersaal (Raum 792), Aufnahme um 1935
Berlin City Palace, Rittersaal (Knights' Hall, room 792), photograph, c.1935

überhaupt das modernste. Schlüters Umbau zeugt von einem tiefen Verständnis für die Möglichkeiten barocker Architektur, deren Ausdruck er durch den treffsicheren Einsatz von Bauplastik noch steigerte. Sein Entwurf offenbart zudem eine eingehende Auseinandersetzung mit der europäischen Baukunst früherer Jahrzehnte, sei es aus Rom, aus Paris oder aus Warschau. So übernahm er vom Palazzo Madama in Rom, um nur ein Beispiel zu nennen, die markante Durchdringung von Mezzaningeschoßfenstern und Abschlußfries, nachdem schon Tilman van Gameren (1632–1706) am Palais Krasiński in Warschau, wo Schlüter als Bildhauer beteiligt gewesen war, auf diese Lösung zurückgegriffen hatte.

where he took up the colossal order developed by Nering. Schlüter later forewent this plan in favour of an aesthetically more convincing two-storey solution with coupled Doric columns on the ground floor (fig. 4), and had the already erected colossal columns removed. Work on the court galleries went on until 1706. They linked the sideward court portal to the portal of the great staircase, which had been completed around 1704 and which represented the high point of the courtyard architecture. The portal led to the royal chambers, the interior furnishings of which were likewise designed entirely by Schlüter and completed in 1706 (figs. 5, 6). In 1701, he was moreover commissioned with the modernisation of the Mint Tower and to raise its height to just under 100 metres. The tower, however, had to be torn down at the height of about sixty metres in the summer of 1706 because it proved to be unstable. As a consequence, Schlüter was dismissed from his palace post.

He was succeeded by Johann Friedrich Eosander von Göthe (1669–1728), who did not execute Schlüter's model but designed a west extension of the palace instead, doubling its size. The exterior of the palace attained its final form by 1716, albeit without the dome, which was first erected around 1850. The palace was largely a burned-out shell at the close of World War II and its ruins were dynamited in 1950/51. In conjunction with the building of the Humboldt-Forum, a reconstruction of the palace's Baroque façades and Schlüter's courtyard is presently underway.

The genesis and significance of the Berlin City Palace is closely tied to the history of Brandenburg-Prussia. It is quite possible that the palace was the most remarkable building ever produced by that state. The Baroque palace was one of most important European residences of its time and stands on equal footing with the Louvre in Paris and the Royal Palace in Stockholm. And in the early 18th century it was certainly the most modern in the Holy Roman Empire. Schlüter's rebuilding efforts testify to a deep understanding of the potentials of Baroque architecture, the expression of which he was able to heighten even further through the unerring employment of architectural sculpture. His plans likewise reveal the extent to which he studied European architecture from earlier centuries, whether from Rome, Paris or Warsaw. To give but one example, he borrowed the striking interlocking of the mezzanine windows and upper frieze from the Palazzo Madama in Rome after Tilman van Gameren (1632–1706) had already taken up this solution in his design for the Krasiński Palace in Warsaw, where Schlüter had previously been active as a sculptor.

II. WERKE SCHLÜTERS IN BERLIN-CHARLOTTENBURG

II. WORKS BY SCHLÜTER IN BERLIN-CHARLOTTENBURG

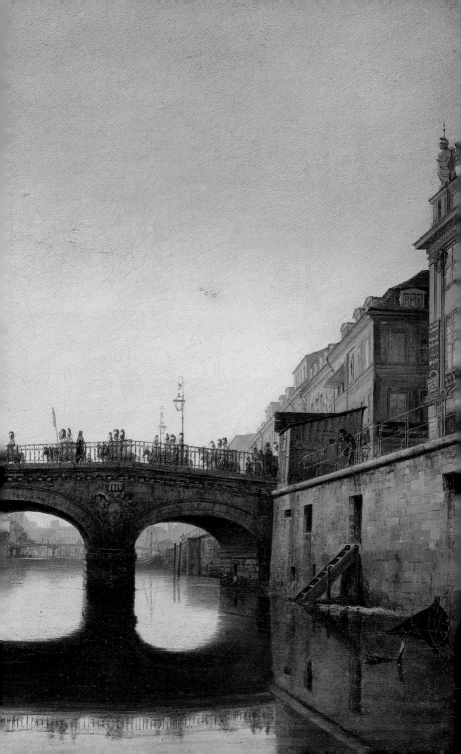

6.
REITERDENKMAL DES GROSSEN KURFÜRSTEN
THE EQUESTRIAN MONUMENT TO THE GREAT ELECTOR

Schloß Charlottenburg, Ehrenhof
Spandauer Damm 20–24

Öffnungszeiten:
1. Apr. – 31. Okt.:
Di. – So. 10.00–18.00 Uhr
1. Nov. – 31. März:
Di. – So. 10.00–17.00 Uhr

Standort 1701–1939:
Lange Brücke (heute Rathausbrücke)

Andreas Schlüter
Guß: *Johann Jacobi* (1661–1726)

Reiterdenkmal des Großen Kurfürsten
Berlin, 1696–1701 | Bronze, Pferd mit
Reiter | H. ca. 350 cm × B. 380 cm ×
T. 190 cm | Sockel H. 285 cm ×
B. 380 cm × T. 200 cm

Sockelschmuck | Guß: *Johann Jacobi*

Johann Hermann Backer | *Cornelius*
Heintzy | *Friedrich Gottlieb Herfert* |
Johann Samuel Nahl (1664–1727)
nach Modellen von *Andreas Schlüter*

Vier Sklaven
Berlin, 1703–1708 | Bronze, H. ca. 200–
225 cm × B. ca. 150–195 cm × T. ca. 150 cm

Johann Samuel Nahl

Allegorie auf das Kurfürstentum
Brandenburg
Berlin, 1708 | Bronze, H. 80 cm × B. 80 cm

Johann Hermann Backer

Allegorie auf das Königtum in Preußen
Berlin, 1708 | Bronze, H. 80 cm × B. 80 cm

Spandauer Damm 20–24
Forecourt of Charlottenburg Palace

Opening times:
April – October,
Tuesdays to Sundays, 10 a.m. to 6 p.m.
November – March,
Tuesdays to Sundays, 10 a.m. to 5 p.m.

Former location 1701–1939:
Lange Brücke (now Rathausbrücke)

Andreas Schlüter
Cast by *Johann Jacobi* (1661–1726)
The Equestrian Monument to the
Great Elector
Berlin, 1696–1701 | Bronze, horse and
rider | H. ca. 350 cm × W. 380 cm ×
D. 190 cm | Pedestal, H. 285 cm ×
W. 380 cm × D. 200 cm

Pedestal ornamentation | Cast by
Johann Jacobi

Johann Hermann Backer | *Cornelius*
Heintzy | *Friedrich Gottlieb Herfert* |
Johann Samuel Nahl (1664–1727)
After models by *Andreas Schlüter*
Four Slaves
Berlin, 1703–1708 | Bronze, H. ca. 200–
225 cm × W. ca. 150–195 cm × D. ca. 150 cm

Johann Samuel Nahl
Allegory on the Electorate of
Brandenburg
Berlin, 1708 | Bronze, H. 80 cm × W. 80 cm

Johann Hermann Backer
Allegory on the Kingdom in Prussia
Berlin, 1708 | Bronze, H. 80 cm × W. 80 cm

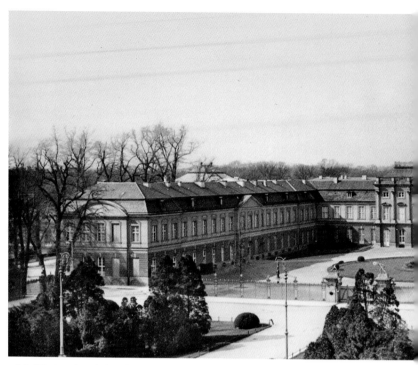

1 Schloß Charlottenburg, Berlin, Aufnahme 1912

Andreas Schlüters berühmtes Denkmal des Großen Kurfürsten (1620–1688) gehört unbestritten zu den herausragenden Reitermonumenten des Barocks (Abb. 2, 3). Als erstes monumentales Reiterstandbild im Heiligen Römischen Reich Deutscher Nation war es um 1700 nicht allein wegen seiner künstlerischen Qualität, sondern vor allem auch in technischer Hinsicht ein absolutes Novum: Der gebürtige Homburger und in Paris ausgebildete Bronzegießer Johann Jacobi (1661–1726) wurde 1695 eigens nach Berlin berufen, um Roß mitsamt Reiter in einem einzigen Guß zu fertigen – im damaligen Kurbrandenburg eine Meisterleistung, die Jacobi mehr Ehre einbrachte als Andreas Schlüter, dem eigentlichen Schöpfer des Denkmals. Doch trotz der hohen Wertschätzung, welches das Reitermonument bis in unsere Tage genießt, dürfte kaum bekannt sein, daß dieses Hauptwerk Schlüters aufgrund seiner Evakuierung zu Beginn des Zweiten Weltkrieges und der anschließenden Teilung Berlins erst 1951 in den Ehrenhof des Charlottenburger Schlosses gelangte. Der ursprüngliche Aufstellungsort des Denkmals war die Lange Brücke (heute

Charlottenburg Palace, Berlin, photograph, 1912

Andreas Schlüter's famed statue of the Great Elector (1620–1688) is undoubtedly one of the most remarkable equestrian monuments of the Baroque period (figs. 2, 3). The first large-scale equestrian statue to be produced in the Holy Roman Empire, it was not only unique as regards artistic quality, but also absolutely innovative in technical terms as well: the Homburg-born and Paris-trained bronze founder Johann Jacobi (1661–1726) was called to Berlin in 1695 for the express purpose of making a sole cast encompassing both horse and rider – a masterly feat in the Electorate of Brandenburg of the time that brought Jacobi more credit and honour than it did Andreas Schlüter, the monument's true author. Regardless of the high esteem in which the equestrian statue is still held today, it is probably not as well known that Schlüter's masterpiece was first erected in the forecourt of Charlottenburg Palace in 1951, subsequent to its evacuation from Berlin at the start of World War II and the division of the city. The monument was originally located on the Lange Brücke (the present-day Rathausbrücke) in the heart of Berlin, which

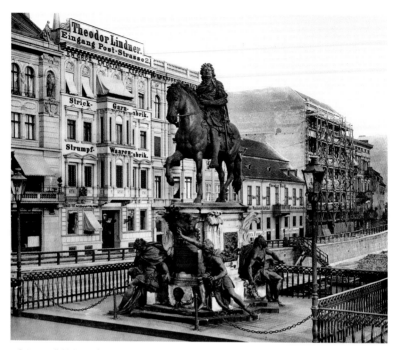

2 Reiterstandbild des Großen Kurfürsten, ehemalige Aufstellung auf der Langen Brücke (1703), Aufnahme vor 1896
Equestrian statue of the Great Elector, former location on the Lange Brücke (1703), photograph, before 1896

Rathausbrücke) im Zentrum Berlins, die seit dem 13. Jahrhundert die beiden unabhängigen Residenzstädte Berlin und Cölln miteinander verband und direkt in den damaligen Schloßplatz mündete (Abb. 2, 4). Kurfürst Friedrich III. (1657–1713) ließ 1692 den noch wenige Jahre zuvor von seinem Vater erneuerten Holzsteg abreißen und nach Plänen seines Hofarchitekten Johann Arnold Nering (1659–1695) durch einen fünfbogigen, erstmals in Sandstein ausgeführten Neubau ersetzen, der von Anbeginn auch eine zentrale Ausbuchtung für ein Reiterdenkmal vorsah. Zunächst wollte Friedrich sich selbst im Reiter verewigt sehen – analog zum 1692 gegossenen Reitermonument Ludwigs XIV. in Paris –, doch fiel 1696 die Entscheidung, stattdessen seinen Vater, Kurfürst Friedrich Wilhelm, in dieser Form zu ehren, der nach der siegreichen Schlacht von Fehrbellin im Jahre 1675 den Beinamen »der Große« führte.

Das Brückenmonument bildete den Anfang eines umfassenden Repräsentationsprogramms, mit dem Friedrich III., motiviert durch sein Streben nach der Königswürde, den Umbau Berlin-Cölln zu einer modernen Residenz vorantrieb.

had connected the two autonomous residence cities of Berlin and Cölln with each other since the 13th century and led directly to the former Schloßplatz (figs. 2, 4). In 1692, Elector Frederick III (1657–1713) caused the wooden footbridge his father had renewed only a few years earlier to be demolished and replaced by a new, five-arched bridge originally built in sandstone after plans drawn by court architect Johann Arnold Nering (1659–1695). From the very beginning, a platform-like extension was added to the bridge as the site for an equestrian monument. Frederick initially intended to have himself immortalised as the rider there – analogous to the 1692 equestrian monument to Louis XIV in Paris – but in 1696 it was decided to give this honour to his father, Elector Frederick William, who was popularly known as 'The Great Elector' after the victorious Battle of Fehrbellin in 1675.

The bridge monument formed the start of a wide-ranging representational programme with which Frederick III, motivated by his aspiration to the royal title, pressed ahead with his efforts to rebuild Berlin-Cölln into a modern residence. He oriented his plans on such notable models as Rome and Paris, and the concept for a bridge monument can accordingly be directly traced to the equestrian statue of Henry IV on the Pont Neuf in Paris. Like in Berlin, this bridge also had a clear view of a palace complex, in this case the Louvre. Begun in 1604 by Giambologna (1529–1608) and completed in 1611 by Pietro Tacca (1577–1649), the equestrian statue was damaged to a large extent in 1792 during the French Revolution. Its appearance is preserved in paintings and prints that show Henry IV on horseback and dressed in contemporary garments. The statue stands on a tall pedestal flanked by four chained slaves. It is particularly the motif of the four captives that Schlüter borrowed for his monument in Berlin, creating a closeness to this formerly famous monument and the king who was popular among his people. Despite his contemporary full-bottomed wig, the elector is dressed *à l'antique*, an unmistakable allusion to the most famous equestrian statue of classical antiquity, namely that of Marcus Aurelius on the Capitoline Hill in Rome, but also to the equestrian statue of the classically dressed Sun King Louis XIV in Paris that François Girardon (1628–1715) executed between 1685 and 1694 for the Place Louis-le-Grand, the present-day Place Vendôme: all of them rode their horses – just like the gods themselves – without stirrups.

In order to entirely comprehend the concept of Schlüter's equestrian monument, we must consider its original placement in the middle of the Lange Brücke (figs. 2, 4): the viewer approaching the bridge from the Berlin side saw the Great

Hierbei orientierte er sich an so glanzvollen Vorbildern wie Rom und Paris. Demgemäß ist auch die Konzeption eines Brückenmonumentes unmittelbar auf das Reiterstandbild Heinrichs IV. auf dem Pont Neuf in Paris zurückzuführen. Wie in Berlin befindet sich diese Brücke ebenfalls in Sichtachse des Schloßareals – des Louvre. 1604 von Giambologna (1529–1608) begonnen und 1611 von Pietro Tacca (1577–1649) vollendet, wurde das Reiterstandbild 1792 während der Französischen Revolution weitgehend zerstört. Gemälde und Graphiken überliefern jedoch sein Aussehen: Sie zeigen Heinrich IV. zu Pferd in zeitgenössischer Tracht auf hohem Sockel, der von vier angeketteten Sklaven flankiert wird. Es ist vor allem das Motiv der vier Gefangenen, das Schlüter in seinem Monument übernommen hat und das die Nähe zu diesem ehemals berühmten Denkmal und dem im Volk beliebten König herstellt. Trotz zeitgenössischer Allongeperücke ist der Kurfürst *à l'antique* gekleidet, eine unmißverständliche Anspielung auf das berühmteste Reiterstandbild der Antike, dasjenige Marc Aurels auf dem Kapitol in Rom, aber auch auf das Reiterstandbild des antikisch gewandeten Sonnenkönigs Ludwig XIV. in Paris, das François Girardon (1628–1715) zwischen 1685 und 1694 für die Pariser Place Louis-le-Grand, die heutige Place Vendôme, ausführte: Sie alle ritten – den Göttern gleich – ohne Steigbügel ihre Pferde.

Um jedoch die Konzeption von Schlüters Reiterdenkmal gänzlich zu verstehen, müssen wir uns die ursprüngliche Plazierung im Zentrum der Langen Brücke vor Augen führen (Abb. 2, 4): Der Betrachter, der, von Berlin kommend, diese betrat, erblickte den Großen Kurfürsten zu seiner Linken, wie Friedrich Wilhelm zu seiner Residenz auf der gegenüberliegenden Cöllnischen Seite hinübersah. Der Reiter hält ihm mit seiner ausgestreckten Rechten den Kommandostab entgegen, während das Pferd mit aufgerichtetem Haupt und zügigen Schrittes nach vorne strebt. Seine Dynamik wird durch die angespannte Muskulatur erzielt, aber auch durch die bewegte, nach oben »aufzüngelnde« Mähne, die, vom Winde erfaßt, aus seiner Stirn weht. Das Reitermonument vermittelt von dieser Seite einen impulsiven, Macht demonstrierenden Eindruck. Eine ganz andere Situation offenbarte sich dem Passanten, der die Brücke vom Schloßareal betrat. Von dort schaute der Große Kurfürst souverän über die Köpfe hinweg, wobei seine Hand mit dem Kommandostab hinter dem Pferd verschwindet, dessen Gangart aus dem veränderten Blickwinkel viel ruhiger wirkt. Das dynamisch Vorwärtsstrebende ist einem gemäßigten Auftritt gewichen, ebenso erscheint die wehende Mähne zurückgenommen. Hier tritt nun der friedensstiftende Aspekt des Monuments in

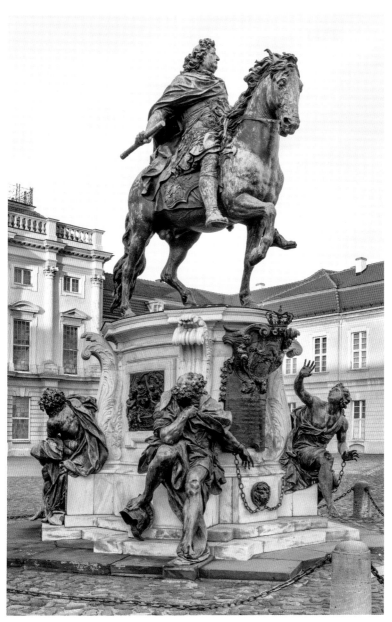

3 Andreas Schlüter und Johann Jacobi, Reiterstandbild des Großen Kurfürsten, 1696–1701, Berlin, Schloß Charlottenburg, Ehrenhof

Andreas Schlüter and Johann Jacobi, equestrian statue of the Great Elector, 1696–1701, forecourt of Charlottenburg Palace, Berlin

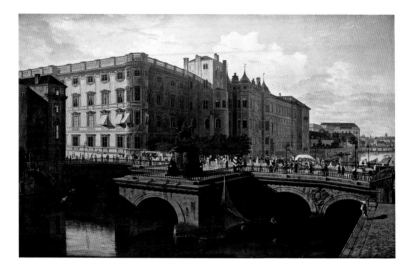

4 Maximilian Roch, Das Schloß und die Lange Brücke mit dem Reiterstandbild des Großen Kurfürsten, um 1830
Maximilian Roch, The Palace and the Lange Brücke with the Equestrian Statue of the Great Elector, c.1830

den Vordergrund – dank der Souveränität und Willensstärke des Großen Kurfürsten, der die Zügel fest in seiner Hand hält und die Geschicke seines Landes lenkt.

Am Sockel sind an den Längsseiten zwei Reliefs angebracht, welche erst 1708 von Johann Jacobi gegossen wurden. Während das Relief auf der linken Seite eine Allegorie auf das Kurfürstentum Brandenburg darstellt und sich somit auf die Regierung des im Reitermonument verewigten Kurfürsten Friedrich Wilhelm bezieht, verherrlicht das zweite Relief – die Allegorie auf das Königtum Preußens – die Regierung ihres Auftraggebers König Friedrich I.

Abschließend sei erwähnt, daß in der großen Kuppelhalle des Bode-Museums eine galvanoplastische Nachbildung des Schlüterschen Reiterdenkmals des Großen Kurfürsten steht, allerdings ohne die vier Sklaven, dafür aber auf dem originalen Sockel. Während der Restaurierungsarbeiten an der Langen Brücke zum Ende des 19. Jahrhunderts mußte der schadhafte Sockel durch einen neuen ersetzt werden und gelangte 1901 als Geschenk in das im Bau befindliche, 1904 dann eröffnete Kaiser-Friedrich-Museum, das spätere Bode-Museum. Wilhelm von Bode (1845–1929) veranlaßte daraufhin den Nachguß des Denkmals. In Charlottenburg befindet sich folglich das originale Bronzewerk Schlüters, der Sockel ist hingegen eine 1951 angefertigte Kopie.

Elector on his left looking across to his residence on the opposing Cölln side. The rider holds out his baton in his outstretched right hand to this onlooker, while his steed pushes forward at a smart pace with his raised head. The dynamics of the horse are shown in his tense musculature on the one hand, but also through the animated, flame-like mane on the other that is caught by the wind and wafts over the animal's forehead. For those crossing the bridge from this side, the equestrian monument conveys the impression of an impulsive demonstration of power. A very different situation is posed to the passerby approaching the bridge from the palace complex on the Cölln side. Seen from this perspective, the Great Elector gazes out commandingly over the heads of those around him; his hand with the baton has disappeared behind the steed, whose pace now makes a much calmer impression. The dynamic forward motion has given way to a much more leisurely pace here and the wafting mane appears less animated. Focus is now placed on the aspect of the peacemaker – thanks to the authority and strong-mindedness of the Great Elector, who holds the reigns firmly in his hand and controls the fate of his land.

Affixed to the side walls of the pedestal are two reliefs that were first cast by Johann Jacobi in 1708. While the relief on the left represents an allegory on the Electorate of Brandenburg, thus referencing the reign of Frederick William, the elector immortalised by the equestrian monument, the second relief – the allegory on the Kingdom in Prussia – glorifies the reign of the monument's patron, King Frederick I.

In closing, it should be mentioned that an electrotype replica of Schlüter's equestrian monument to the Great Elector stands in the great domed hall of the Bode-Museum – albeit minus the four slaves, but in any case on the original pedestal. The damaged original pedestal had to be replaced by a new one during the restoration of the Lange Brücke in the late 19th century. It was presented as a gift to the Kaiser-Friedrich-Museum (the present-day Bode-Museum) in 1901 while the museum, which would open in 1904, was still under construction. Wilhelm von Bode subsequently arranged for a cast to be made of the monument. Schlüter's original bronze sculpture accordingly stands in Charlottenburg on a copy of the pedestal dating from 1951.

Thomas Fischbacher

7.
DIE BRONZESTATUE DES KURFÜRSTEN FRIEDRICH III.
THE BRONZE STATUE OF ELECTOR FREDERICK III

Schloss Charlottenburg, Neuer Flügel, Spandauer Damm 20–24

Charlottenburg Palace, New Wing, Spandauer Damm 20–24

Andreas Schlüter
Guß: *Johann Jacobi* (1661–1726)
Die Bronzestatue des Kurfürsten Friedrich III.
Berlin, 1698 (nicht erhalten) | Nachguß 1972 | Bronze, H. ca. 213 cm

Andreas Schlüter
Cast by *Johann Jacobi* (1661–1726)
The Bronze Statue of Elector Frederick III
Berlin, 1698 (lost) | new cast, 1972 | Bronze, H. ca. 213 cm

1 Andreas Schlüter und Johann Jacobi, Denkmal für Kurfürst Friedrich III., Königsberg in Preußen, Aufnahme 1913
Andreas Schlüter and Johann Jacobi, statue of Elector Frederick III, Königsberg (Kaliningrad), photograph, 1913

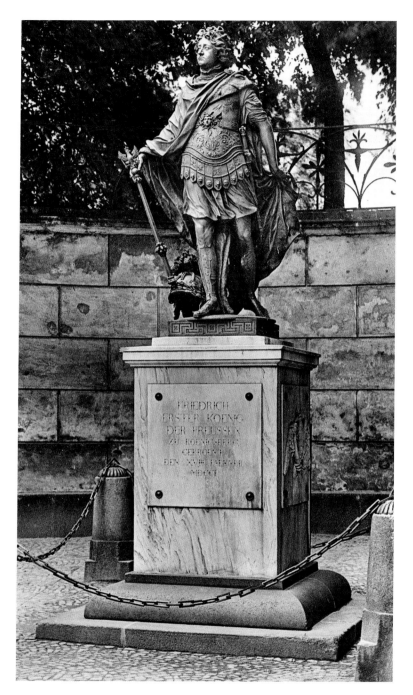

Die Entstehung der Bronzestatue *Friedrich zu Fuß* ist eng mit dem Werden eines anderen Bildwerkes verknüpft, nämlich der Reiterstatue auf der Langen Brücke in Berlin, die heute vor dem Schloß Charlottenburg aufgestellt ist. Schon seit 1692 hatte Kurfürst Friedrich III. (1657–1713) die Absicht, sich selbst in dem Reiterbild portraitieren zu lassen. Es gelang ihm allerdings nicht, das Vorhaben wie geplant zu verwirklichen. Konsens fand schließlich der alternative Plan, den verstorbenen Vater Friedrich Wilhelm, den Großen Kurfürsten (1620–1688), in dem Reiterstandbild darzustellen, der regierende Kurfürst Friedrich III. beschied sich in der Folge mit einem Standbild im Zeughaus. Beide Kunstwerke wurden von Andreas Schlüter geformt und von Johann Jacobi in Bronze gegossen, wobei das Standbild Friedrichs 1698 als erstes vollendet war. Die Statue ist jedoch nie im Hof des Zeughauses aufgestellt worden. Erst nachdem unter König Friedrich Wilhelm I. (1688–1740) an dem Standbild einige Veränderungen vorgenommen wurden, ist es erstmals 1728 auf dem Berliner Molkenmarkt auf einen Sockel gehoben worden, umgeben von vier gipsernen Sklaven eines unbekannten Bildhauers, die 1733 bis 1737 in Bronze gegossen wurden. 1739 brach man das Denkmal ab und begann einen repräsentativeren Neubau auf der Prachtstraße Unter den Linden, der jedoch unvollendet blieb. Die Bronzen wurden im Zeughaus deponiert. Erst ein Anstoß aus Bürgertum und Adel befreite die Herrscherstatue wieder aus ihrer Haft: In Teilen umgearbeitet, ist sie 1802 ohne die Sklaven auf Befehl König Friedrich Wilhelms III. (1770–1840) vor dem Königsberger Schloß aufgestellt worden (Abb. 1). 1944/45 wurde *Friedrich zu Fuß* in ein nahegelegenes Fort in Sicherheit gebracht, das weitere Schicksal der Statue ist unbekannt. Glücklicherweise konnten von einem früher abgenommenen Gipsabguß auf Betreiben des Bildhauers Gerhard Marcks (1889–1981) 1972 zwei Kopien in Bronze gegossen werden: Eine erhielt das Bode-Museum, die andere bekam 1979 ihren Platz auf einer Rekonstruktion des Königsberger Sockels vor dem Schloß Charlottenburg (Abb. 2).

Als Schlüter die Statue schuf, »marschierte« sie wie heute auf einem runden Schild, der unten fest mit einer Plinthe verbunden war. Die frühere Ausformung von Schild und Plinthe ist allerdings nicht bekannt, die heute sichtbaren Teile sind Ergänzungen aus der Zeit des Klassizismus. Friedrich ist antikisierend gekleidet: Er trägt Sandalen, floral geschmückte Beinschienen und bis über die Knie reichende Hosen, darüber ein knapp oberhalb der Knie endendes Untergewand. Auf diesem liegt ein kurzer Panzer, der an der Hüfte mit beweglich zu denkenden Streifen abschließt. Den Panzer schmücken unten stilisierte Akanthusblätter, oben ist auf der

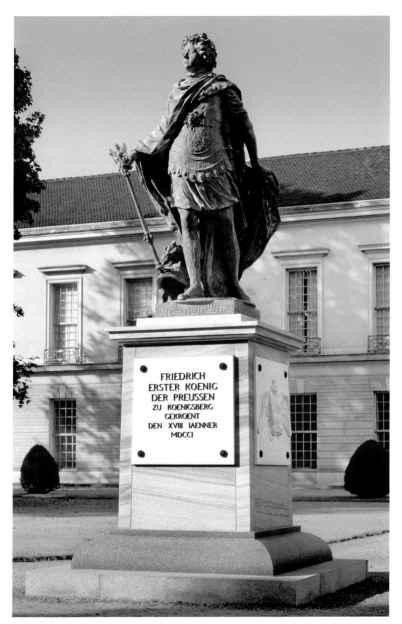

2 Nach Andreas Schlüter, Standbild Friedrichs I., Bronzenachguß von 1972 nach Modell von 1698 (Staatliche Gipsformerei Berlin), Original seit 1945 verschollen, Berlin, Schloß Charlottenburg vor Knobelsdorff-Flügel
After Andreas Schlüter, statue of King Frederick I, bronze cast, 1972 (original lost since 1945), after a model from 1698 (Staatliche Gipsformerei Berlin), in front of the Knobelsdorff Wing of Charlottenburg Palace, Berlin

3 Martin Brunner, Medaille auf die Krönung Josephs I. von Österreich, 1690
Martin Brunner, coronation medal of Joseph I of Austria, 1690

linken Seite der Bruststern des englischen Hosenbandordens sichtbar. Die Taille
wird durch einen Gürtel mit einer Medusa markiert, an dem links ein Schwert
in einer Scheide hängt. Über beide Schultern und den rechten Arm liegt ein bis
zum Boden reichender Mantel, der teilweise umgeschlagen ist und sein Futter aus
Hermelin sehen läßt. Mit seinem linken Arm greift Friedrich schwungvoll nach
hinten in diesen Mantel. In der rechten, nach vorne gestreckten Hand hielt er einst
das Kurzepter, das er auf einen am Boden liegenden Helm stützte. Bereits um 1713
und nochmals nach 1814 wurde es durch das heute sichtbare, königlich-preußische
Zepter ersetzt. Der zu Friedrichs Füßen liegende frühneuzeitliche Helm ist durch
perlenbesetzte Bügel wie eine souveräne Krone geformt, mit Hermelin und Lor-
beer geschmückt und darüber mit einem großen Federbusch geziert. Der Kopf des
Kurfürsten ist leicht nach halbrechts gewendet. Seine lockige Frisur bedeckt die
Ohren nur halb und läßt den Nacken frei. Auf seinem Haupt trägt er nichts.

Schlüters Kunst bestand nicht im Erfinden, sondern vielmehr im Finden und
Verbinden von Motiven. Seine Statue *Friedrichs zu Fuß* ist eine Komposition im
wahrsten Sinne des Wortes: Er stellte sie aus fremden Komponenten zusammen

The genesis of the bronze statue *Frederick on Foot* is closely tied to the history of another sculpture, namely the equestrian statue on Berlin's Lange Brücke (the present-day Rathausbrücke), which now stands before Charlottenburg Palace. Elector Frederick III had already intended to have an equestrian statue of himself made in 1692, but did not succeed in implementing this undertaking as planned. A consensus was finally reached for an alternative scheme, according to which the equestrian monument would depict his deceased father, Frederick William, the Great Elector (1620–1688), while the reigning Elector Frederick III would modestly make do with a statue in the Zeughaus (Old Arsenal). Both artworks were sculpted by Andreas Schlüter and cast in bronze by Johann Jacobi, whereby the statue of Frederick was the first to be completed in 1698. It was, however, never erected in the Zeughaus courtyard. After a few modifications were carried out on it under King Frederick William I of Prussia (1688–1740), the statue was raised on a pedestal and erected in 1728 for the first time on Molkenmarkt in Berlin, where it was surrounded by four plaster slaves by an unknown sculptor that were subsequently cast in bronze between 1733 and 1737. This monument was dismantled in 1739 and work was begun on a new and more representative Unter den Linden. The project remained unfinished and the bronzes were deposited in the Zeughaus. The statue was only released from captivity there following an initiative on the part of both the bourgeoisie and the nobility. Reworked in parts, the statute (minus the slaves) was erected at the command of King Frederick William III (1770–1840) before the castle in the East Prussian city of Königsberg (today Kaliningrad, Russia) in 1802 (fig. 1). In 1944/45, *Frederick on Foot* was taken for safekeeping to a nearby fortification; the statue's subsequent fate is unknown. At the instigation of the sculptor Gerhard Marcks (1889–1981), two bronze copies could fortunately be made in 1972 from an older plaster cast of the statue. One of the casts was presented to the Bode-Museum, the other was placed on a reconstruction of the Königsberg pedestal and relocated to a site before the New Wing of Charlottenburg Palace in 1979 (fig. 2).

At the time Schlüter created the statue, it 'marched', as it still does today, on a round shield that was firmly attached to a plinth at the bottom. The original form of the shield and plinth are unknown; the parts visible today are classicistic additions. Frederick is dressed in classical style wearing sandals, platelegs decorated with floral patterns, braccae that reach to just below the knees, and a skirt above it that ends just above the knees. He wears a short cuirass over it, to which

4 Martin Brunner, Medaille auf die Krönung Josephs I. von Österreich, 1690
Martin Brunner, coronation medal of Joseph I of Austria, 1690

und verband sie zu einem überzeugenden Ganzen. Bei der leichtfüßigen Bein-
stellung bediente er sich einer berühmten Antike, des *Apoll vom Belvedere*, die
für die Zeit wie für die Person untypische Kurzhaarfrisur ist ein Zitat der Statue
Friedrichs III. von Gabriel Grupello (1644–1730), außerdem nahm er Anleihen
bei Kostüm, Haltung und Beiwerk einer französisch geprägten Statue Friedrichs
von Johann Christoph Döbel (1640–1713), das sehr seltene Motiv einer auf einem
Schild stehenden Figur ist hingegen einer Medaille entlehnt, die Martin Brunner
(1659–1725) 1690 zur Wahl und Krönung des nachmaligen Kaisers Joseph I. zum
Römischen König verfertigte (Abb. 3, 4). Schlüters *Friedrich zu Fuß* hätte zusam-
men mit Kriegerköpfen und Riesenkanonen im Zeughaus ein Ensemble bilden
sollen, dessen Aussage heute nur noch ansatzweise zu entschlüsseln ist. Mit der
Wahl des markanten Schildmotivs im Standbild Friedrichs III. wird, mit welcher
genauen Stoßrichtung auch immer, thematisch die Erlangung der Souveränität
durch die angestrebte Königswürde verkörpert worden sein, die der Kurfürst vom
Kaiser zu erlangen wünschte.

movable fauld bands have been affixed at the hips. The cuirass is decorated below with stylised acanthus leaves, while the emblem of the English Order of the Garter is emblazoned at the upper left. The elector furthermore wears a waistbelt ornamented with a Medusa head and from which a sword hangs in a sheath on his left. An ermine-lined cloak extends down to the ground from over both shoulders and his right arm. Frederick energetically reaches back with his left arm into the cloak. He originally held the short sceptre in his right hand, which is extended forward, propping it up on the helmet lying on the ground next to him. As early as 1713, and again after 1814, it was replaced with the present-day Royal Prussian sceptre. The early modern helmet lying at Frederick's feet features a pearl-beaded half-arch like a sovereign's crown and is decorated with ermine and laurel and ornamented with a large plume of feathers. The elector's head is turned slightly to his right. His ears are only partially covered by his curly hair, leaving the neck free. He wears nothing on his head.

The distinguishing feature of Schlüter's art was not that he invented motifs but rather found and merged them to form a convincing whole. His statue depicting *Frederick on Foot* is a composition in the truest sense of the word. The artist assembled its parts from a variety of different components. Schlüter modelled the light-footed position of the legs after a famous source from classical antiquity, namely the *Apollo Belvedere*, while the anachronistic and for Frederick III untypical short hairstyle quotes the statue of the elector by Gabriel Grupello (1644–1730). Schlüter furthermore borrowed elements from a French-influenced statue of Frederick by Johann Christoph Döbel (1640–1713) for the garments, pose and accoutrements, while the very rare motif of a figure standing on a shield was derived from a medal produced by Martin Brunner (1659–1725) on the occasion of the election and coronation of the future Emperor Joseph I as King of the Romans in 1690 (figs. 3, 4). Schlüter's *Frederick on Foot* was intended to form an ensemble together with warrior heads and giant cannons in the arsenal, the meaning of which can only be rudimentally deciphered today. For whatever precise objective, the selection of the distinctive shield motif for the statue of Frederick III thematically embodies the attainment of the sovereignty through the aspired-to royal title, which the elector wished to obtain from the emperor.

BILDNACHWEIS | PICTURE CREDITS

© Archiv des Autors | Archive of the author: Abb. S. | Figs. p. 58

© Bildarchiv Preußischer Kulturbesitz, Staatliche Museen zu Berlin/Eigentum des Hauses Hohenzollern: Abb. S. | Figs. p. 70

© Brandenburgisches Landesamt für Denkmalpflege und Archäologisches Landesmuseum, Messbildarchiv, Wünsdorf: Abb. S. | Figs. pp. 18/19, 27, 35, 37, 43, 51, 57, 64/65, 66, 73

© Markus Hilbich, Berlin: Frontispiz | Frontispiece, Abb. S. | Figs. pp. 20, 23, 38, 45, 46, 48, 69

© Landesarchiv Berlin, Kartenabteilung: Vordere Umschlagklappe | Front cover flap

© Photo Scala, Florenz | Florence – courtesy of the Ministero per i Beni e le Attività Culturali: Abb. S. | Figs. p. 41

© Staatliche Museen zu Berlin – Preußischer Kulturbesitz, Münzkabinett: Abb. S. | Figs. pp. 76, 78

© Staatsbibliothek – Preußischer Kulturbesitz, Berlin, Kartenabteilung:
Hintere Umschlagklappe | Back cover flap, Abb. S. | Figs. pp. 8/9, 10/11, 12/13

© Staatsgalerie Stuttgart: Abb. S. | Figs. pp. 60/61

© Stiftung Preußische Schlösser und Gärten Berlin-Brandenburg, Potsdam: Abb. S. | Figs. pp. 54, 55 / Fotograf | photographer: J. P. Anders: Abb. S. | Figs. p. 75 / Fotograf | photographer: G. Murza: Abb. S. | Figs. pp. 14/15

© Stiftung Stadtmuseum, Berlin: Abb. S. | Figs. pp. 52/53

Reproduktionen | Reproductions: Heinz Ladendorf, *Der Bildhauer und Baumeister Andreas Schlüter*, Berlin 1935, Abb. S. | Figs. pp. 28, 31

Umschlaggestaltung: Entwurf von Sabine Frohmader | Cover design: Concept by Sabine Frohmader
unter Verwendung folgender Bildvorlagen | using the following images:

Vorderseite und vordere Klappe
(von links oben nach rechts unten) |
Front cover and flap (from top left to bottom right):

1. Johann Arnold Nering, Plan der Hauptfassade des Berliner Zeughauses mit einer Graphitskizze der Schlüterschen Schwebekartusche, © Hannover, Gottfried Wilhelm Leibniz Bibliothek – Niedersächsische Landesbibliothek

2. Christian Bernhardt Rhode, Supraporte des Männlich-Grabmals von Andreas Schlüter, © Staatliche Museen zu Berlin – Preußischer Kulturbesitz, Kupferstichkabinett

3. Paul Decker d. Ä. nach Andreas Schlüter, Entwurf für die Lustgartenfassade, © Potsdam, Stiftung Preußische Schlösser und Gärten Berlin-Brandenburg, Graphische Sammlung

4. Johann Georg Wolffgang d. Ä., Reiterdenkmal des Großen Kurfürsten Friedrich Wilhelm, © Stiftung Stadtmuseum Berlin

5. Paul Decker d. Ä., Entwurf für die Schloßplatzfassade des Berliner Schlosses, © Potsdam, Stiftung Preußische Schlösser und Gärten Berlin-Brandenburg, Graphische Sammlung

6. C. H. Horst (zugeschrieben), Grundriß des Paradegeschosses, © Stiftung Stadtmuseum Berlin

Rückseite und hintere Klappe
(von links oben nach rechts unten) |
Back cover and flap (from top left to bottom right):

1. Christian Friedrich Gottlieb von dem Knesebeck, Treppenhaus im Portal I, Grundriß Erdgeschoß und erstes Obergeschoß, aus: Kurtze Remarquen, © Schwerin, Staatliches Museum

2. Christian Bernhardt Rode, Prunksarg Königin Sophie Charlottes, © Berlin, Stiftung Deutsches Historisches Museum, Graphische Sammlung

3. Andreas Schlüter, Aufriß der Gartenfassade der Villa Kameke, © Potsdam, Stiftung Preußische Schlösser und Gärten Berlin-Brandenburg, Graphische Sammlung

4. Johann Arnold Nering, Erdgeschoß der Osthälfte des Berliner Zeughauses, Grundriß, © Hannover, Gottfried Wilhelm Leibniz Bibliothek – Niedersächsische Landesbibliothek

5. Jacob Wilhelm Heckhenauer nach Andreas Schlüter, erster Entwurf für das Große Treppenhaus, Längsschnitt, ©Potsdam, Stiftung Preußische Schlösser und Gärten Berlin-Brandenburg

6. Anonymus, Aufriß der Spreefassade der Alten Post, aus: Architectonische Fassaden Berlinischer Palläste, und öffentlicher Gebäude, 1. Heft, Berlin 1793, Nr. 5, © Potsdam, Stiftung Preußische Schlösser und Gärten Berlin-Brandenburg, Graphische Sammlung

Frontispiz | Frontispiece: Andreas Schlüter, Kanzel (Detail: Schalldeckel), 1703, Berlin, Marienkirche | p. 2: Andreas Schlüter, pulpit (detail: sounding board), 1703, St Mary's Church, Berlin

S. 14/15: Eduard Gaertner, Der Kleine Hof des Berliner Schlosses, 1830, Schloß Charlottenburg, Stiftung Preußische Schlösser und Gärten Berlin-Brandenburg | pp. 14/15: Eduard Gaertner, Small Courtyard of the Berlin City Palace, 1830, Charlottenburg Palace, Stiftung Preußische Schlösser und Gärten Berlin-Brandenburg

S. 60/61: Eduard Gaertner, Die Lange Brücke mit dem Reiterstandbild des Großen Kurfürsten Friedrich Wilhelm vom Wasser aus gesehen, 1842, Stuttgart, Staatsgalerie | pp. 60/61: Eduard Gaertner, The Lange Brücke and the Equestrian Monument to the Great Elector Frederick William, Seen from the Water, 1842, Staatsgalerie, Stuttgart

Trotz sorgfältiger Recherche war es nicht in allen Fällen möglich, die Rechteinhaber zu ermitteln. Berechtigte Ansprüche werden selbstverständlich im Rahmen der üblichen Vereinbarungen abgegolten. | In spite of our best efforts, it has not always been possible to discover the owners of the rights to the pictures. Any justified claims in this regard will of course be recompensed under the usual agreements.